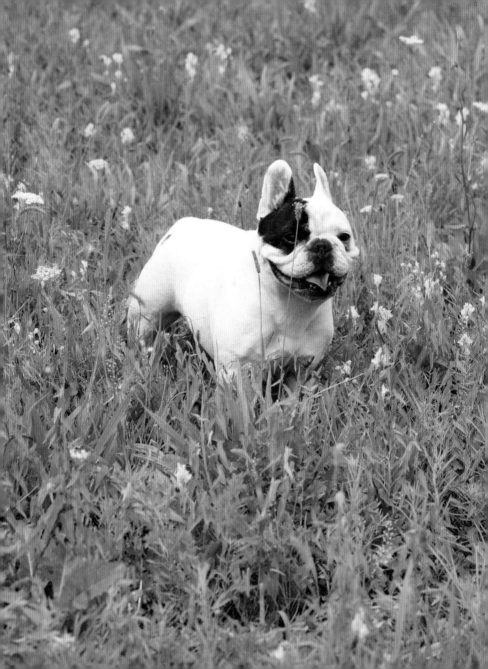

MANNY
THE FRENCHIE'S
ART OF
HAPPINESS

HOW TO LIVE A FULFILLING LIFE
FROM THE WORLD'S
MOST INFLUENTIAL BULLDOG

BY Manny the Frenchie

Touchstone

NEW YORK LONDON TORONTO SYDNEY NEW DELHI

TOUCHSTONE

An Imprint of Simon & Schuster, Inc.
1230 Avenue of the Americas
New York, NY 10020

First Touchstone hardcover edition June 2017

TOUCHSTONE and colophon are registered trademarks of Simon & Schuster, Inc.

For information about special discounts for bulk purchases,
please contact Simon & Schuster Special Sales at 1-866-506-1949 or
business@simonandschuster.com.

The Simon & Schuster Speakers Bureau can bring authors to your live event. For more information or to book an event contact the Simon & Schuster Speakers Bureau at 866-248-3049 or visit our website at www.simonspeakers.com.

Cover and interior design by Shawn Dahl, dahlimama inc

Manufactured in the United States of America

10 9 8 7 6 5 4 3 2 1

Library of Congress Control Number 2017939054

ISBN 978-1-5011-5827-8
ISBN 978-1-5011-5829-2 (ebook)

Cover photo and pages iv; 14 (top); 30; 64-65; 68; 71 (bottom); 90-91; 94-95; 114; 115; 128-129; 130; 131; 132; 133 by Michael Nguyen.

Pages iii; 11 (bottom); 12-13; 37; 38; 40; 42-43; 46; 47; 49; 56-57; 58; 62 (bottom); 63; 100; 101; 105 (bottom); 137; 140-141; 145; 146; 150 by Christian Chavez.

Pages vi; 24; 82-83; 136; 142 by Austin Stevens.

Pages 1; 31; 32; 116; 117; 120; 121; 123; 124; 125; 126 by Esther and Min Chang.

Pages 16; 17; 69; 112; 113; 138; 139; 149 by Timothy Shumaker.

Pages 18; 21; 23; 86 by Andrew Marttila.

Pages 25; 70; 71 (top); 72-73 by PetSmart. All rights reserved.

Pages 118; 119 by Melissa and Paul Canda.

All other photos by Amber Chavez and Jon Huang.

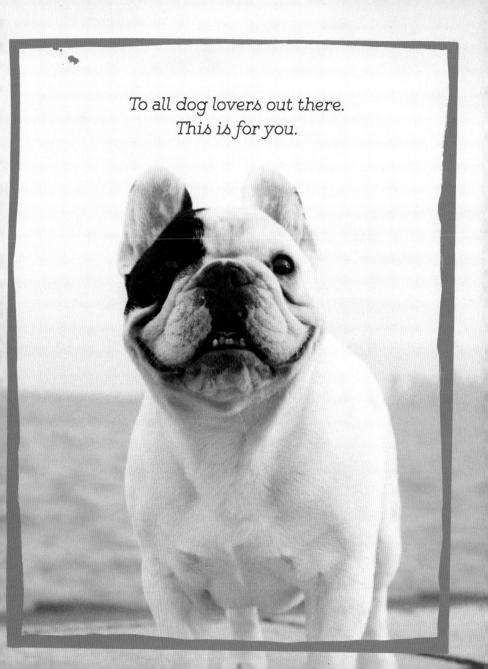

To all dog lovers out there.
This is for you.

AUTHOR'S NOTE

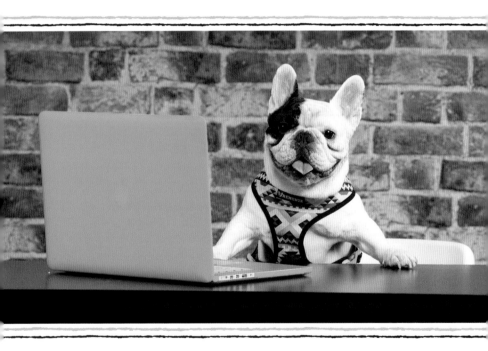

Dear Reader,

I'm thrilled that you're reading my book! I'm even happy you're holding it in your hands or paws or (if it's far, far in the future) your robot pincers. When I sat down to write my memoir, I thought it would be a simple story of a particularly lucky dog's life: mine. I have (and you know this if you've followed me on social media or even just flipped through the photos in this book) gotten to do a whole bunch of really cool stuff in my life (i.e. go on TV, hang with Snoop Dogg, ride in helicopters).

But really, those are small bones compared to the satisfactions of my daily life with my mom, Amber, and dad, Jon, and my three brothers and sister—Frank, Filip, Liam, and Leila. See, it turns out my best moments are also the simplest: sleeping, snuggling with my family, jumping for treats, dressing up in costumes because they make my mom laugh, and sleeping in whatever sink (wait for it . . .) will fit my Frenchie physique. Without exactly meaning to, I've discovered the secrets to sleeping—I mean living—a happy and fulfilling life. And I can't wait to share them with you.

But first, there is one last important detail: my life's passion is helping. Whether raising money for a dog shelter to afford the supplies they need, rescuing pups from a puppy mill, or visiting kids in a hospital, I love to make creatures of all kinds smile. Giving back is truly gratifying.

In each chapter of this book, I'll offer you tips and ideas for how to bring joy to your own life. Naturally, along the way, I'll tell you stories about my life, my family, and my amazing adventures. (And how to deal with having a certain brother named Frank—I mean, I love him, but that Frenchie drives me crazy!)

Every word in this book is the honest truth. I hope these pages make you smile, but mostly I hope they help you realize: a great dog's—or human's—life is more than eating, sleeping, and going out for "productive" walks. It's about being a helper and spreading love. This is, of course, the most fulfilling feeling of all.

At the back of this book is a list of my favorite charities. Please visit their websites and do what you can; I've found it's a big part of being happy.

Thanks for reading and enjoy!

Much love and happiness,

Manny the Frenchie

FUN FACTS*

FRENCH BULLDOG

MY BREED!

***COURTESY OF THE AMERICAN KENNEL CLUB**

🐾 Watch us around the pool! Most Frenchies cannot swim due to our somewhat "bulbous" bodies. I happen to be especially buoyant, though, so I do get to indulge. But swimming and bullies don't always go together.

🐾 Like the Winston Churchill–esque gentlemen we resemble, we require a brisk daily walk to keep us in shape.

🐾 Frenchies are the sixth most popular breed of dog (and rising fast!).

🐾 Our ears are called "bat ears" (due to the shape). Not flattering, but true.

🐾 If we pant too much, our throats can swell up and we can asphyxiate ourselves—that means we can't breathe! So crank up the AC, please.

🐾 We have the ability to jump like jackrabbits, as high as a meter. Especially for treats held higher than a meter above our heads.

🐾 Frenchies are well suited to apartment living, family life, and other pets. Adopt a Frenchie today!

SLEEP

MORE
IS
MORE

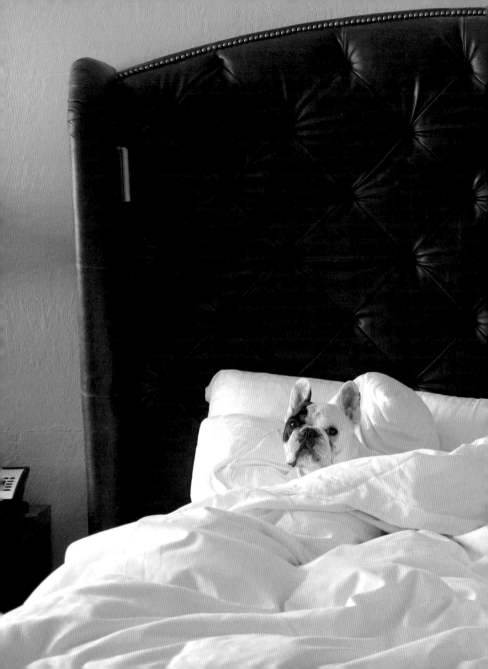

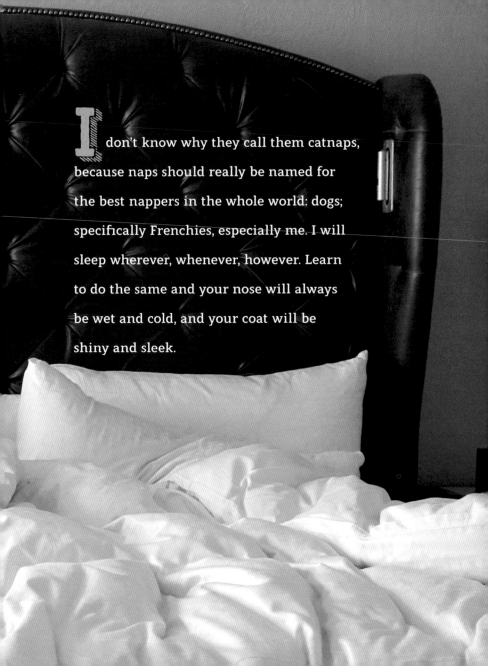

I don't know why they call them catnaps, because naps should really be named for the best nappers in the whole world: dogs; specifically Frenchies, especially me. I will sleep wherever, whenever, however. Learn to do the same and your nose will always be wet and cold, and your coat will be shiny and sleek.

For us dogs, sleep isn't simply that thing you get when it's too dark to see. It's everything: rest, dreamtime, closeness, a cure-all for the cares of an often too loud and big world. Whenever someone I love is feeling down, I have one word of advice: take a nap. Life is always better after a little shut-eye.

Want to know the best secret (don't tell)? At night, my siblings and I pile in with Mom and Dad. They have a king-size bed. I think we should get a bed as big as the whole room! Frank (of course) is the only loner. He loves to be in his cage, the weirdo. But he's another story, and I'll tell you about him later.

The funny thing about sleep and me is, you wouldn't even be reading this book if it wasn't for my need to nap anytime, anywhere.

It all happened like this: One morning, Mom and Dad were in the bathroom brushing their teeth.

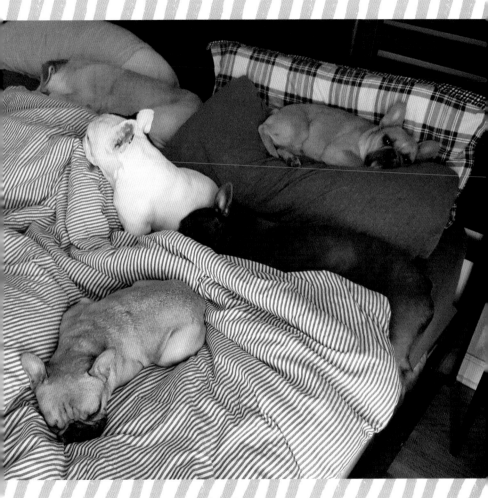

#bedcoup

"You're getting underfoot again, Manny boy," Mom said. "I don't want to trip on you."

"Well I don't mind," I wanted to say back, but all I could do was *aroo* in my Frenchie talk (again, more on this later).

"Fine—you want to get on the counter? Anything for you," Mom said. I guess she thought I was trying to climb up next to her, but I really was wondering what kind of food she might have up there where I couldn't see.

But there were just hairbrushes and spray bottles and soap (which I'd already learned the hard way is NOT for eating). Mom was taking forever to get ready and now I was quite seriously overdue for my nap. I couldn't get off the high, slippery countertop by myself, though.

Then I realized: The bathroom sink was just my size! I tested the inside with my left paw—wet and cool, pleasant on a hot day. So I scuttled myself down into the bowl. Then, exhausted, I curled up, closed one eye, blinked the other, and settled down to SLEEP.

ZZZzzz...ZZZzzz...

I'd always been happy; I was *born* happy. On that day, however, snoozing in the sink and hearing Mom's giggle through my dreams of treats... Well, the art of happiness starts here: with family, laughter, and a comfortable place to catch some zzz's on a hot day.

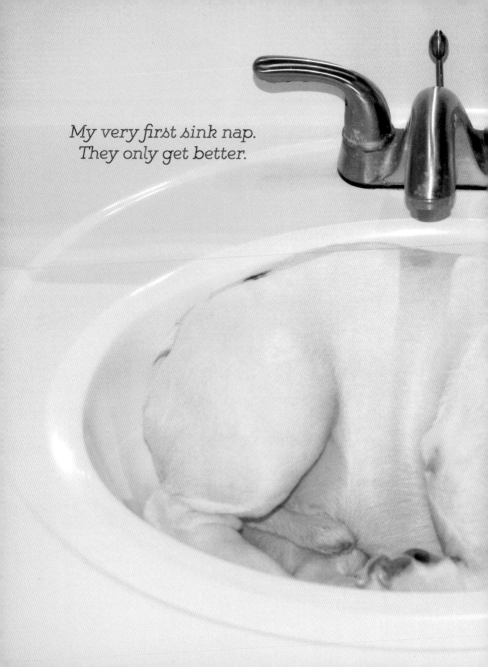

My very first sink nap.
They only get better.

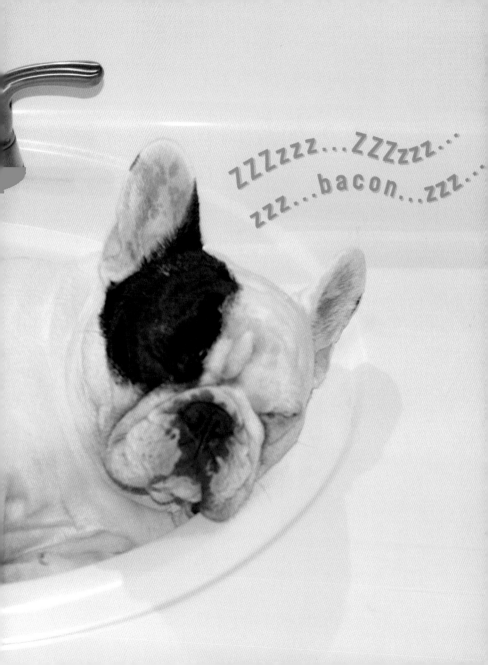

Sleep Is the
Most Important Thing
in the World.

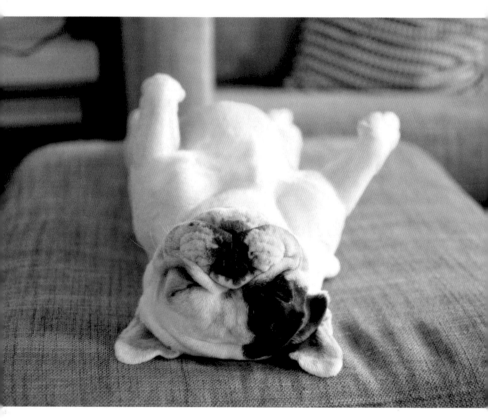

10

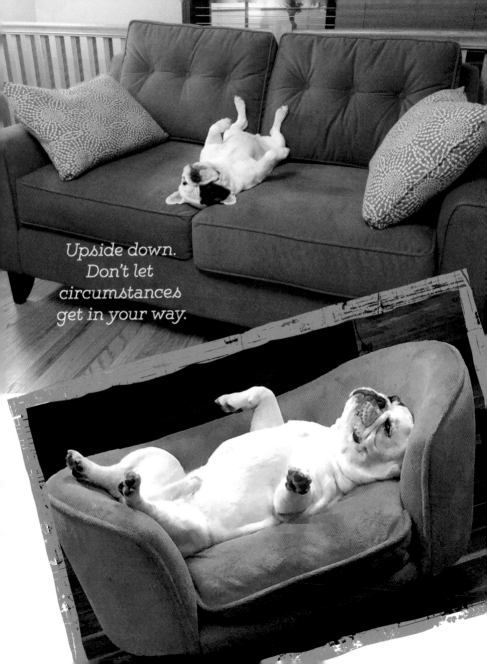

Upside down.
Don't let
circumstances
get in your way.

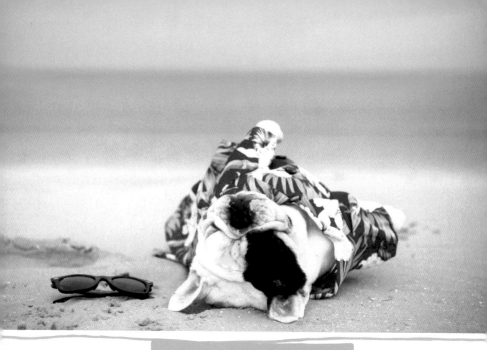

I have it good, I know.

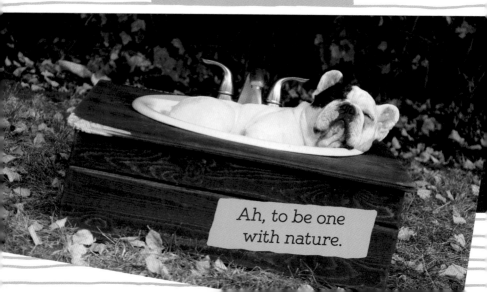

Ah, to be one
with nature.

Love my faux fur beanbag chair.
Note the word FAUX! No animals were
harmed in the taking of this photograph.

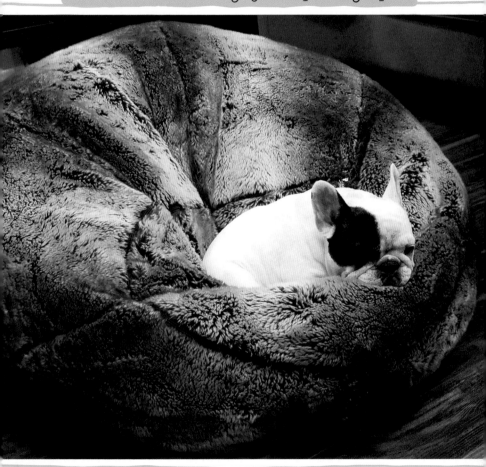

EXPRESS YOURSELF!

OR,
A
HUMAN'S
GUIDE
TO
FRENCHIE
TALK

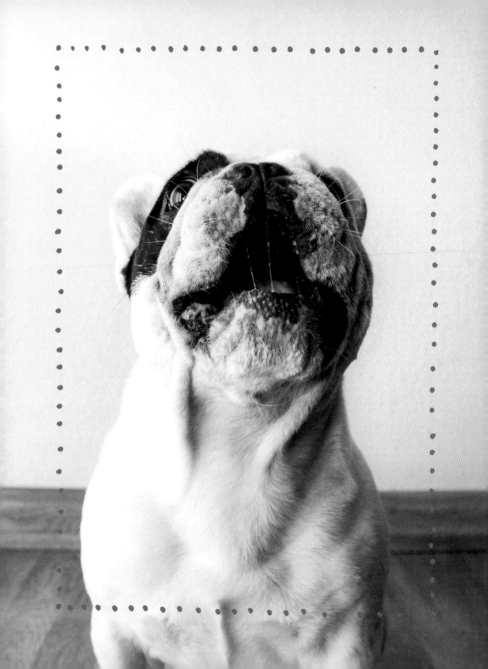

Those of you who've watched my videos may have noticed that I…make funny noises. Most dogs bark, but I don't even know how. Instead, when I want a treat, or when I'm nervous, or even when Mom and Dad or one of my siblings leaves the room and I want them to stay, I talk.

Most of my noises sound like *aroos* or *groop groops*.
Sometimes they're close to an *arf* or a snort.

On occasion, I'll Frenchie talk just to be funny.
I wish my siblings could do it too. Maybe I'd be able
to finally plan that complete takeover of Mom and
Dad's bed that we've been trying. . . .

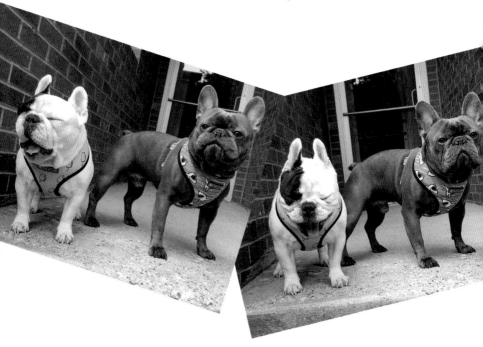

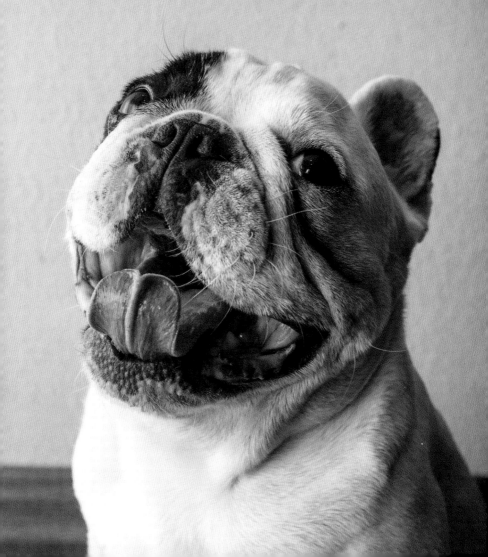

#frenchietalk

For the record, my brother Frank doesn't talk. He snorts and I guess that's fine. The point is, it's important to speak your mind; don't let things fester. Oftentimes I find my sister, Leila, keeps things bottled up, and then she gets a stomachache.

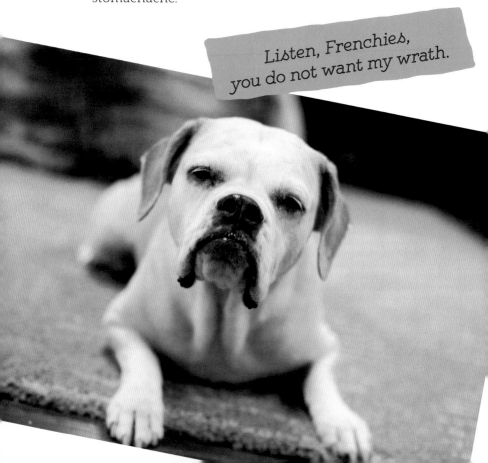

Listen, Frenchies, you do not want my wrath.

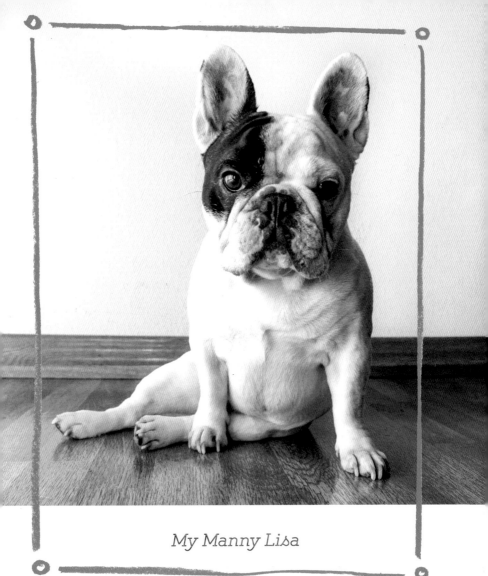

My Manny Lisa

23

FIVE REASONS TO SMILE RIGHT NOW:

1. You're reading a book written by a French bulldog!

2. Naps are free.

3. Leading experts agree that owning a dog can lead to a healthier and happier life.

4. According to the ASPCA (one of my favorite orgs), approximately 2.7 million shelter animals were adopted last year. (What are you waiting for?)

5. Sometimes I'm Batman.

24

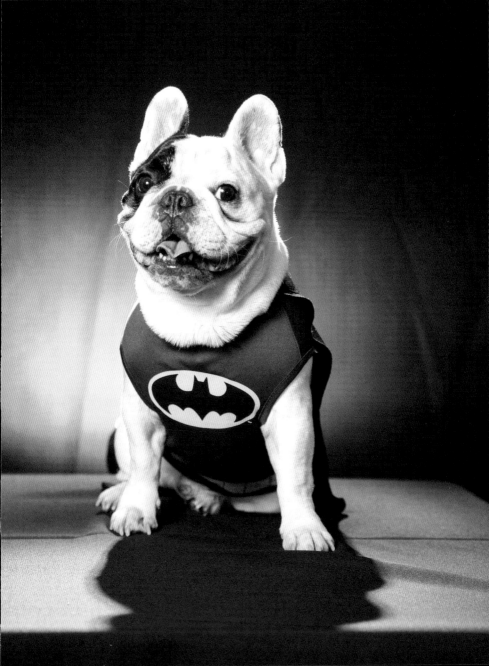

CHAPTER

3

FAMILY,

FOREVER,
NO MATTER
WHO GETS THE
BIGGEST
TREAT

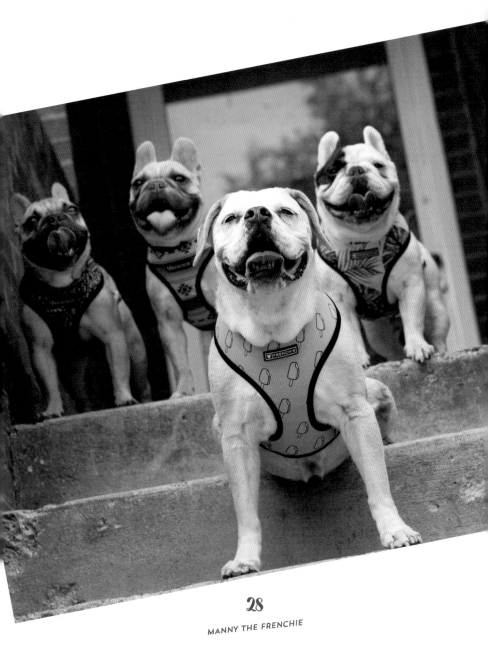

28

MANNY THE FRENCHIE

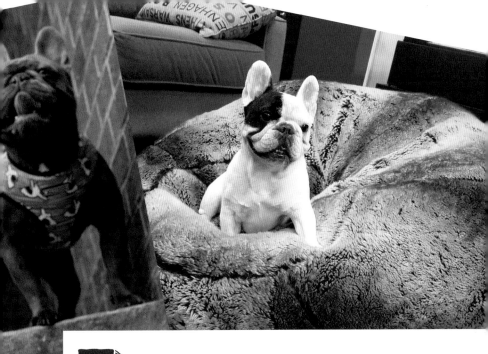

Family, they only make you stronger... and happier! (Well, most of the time.) I feel very lucky to have a big family. However, we are a LOT of dog in one Chicago apartment, and I am not a fan of rationing food—AT ALL. Nor do I like it when someone steals my spot on the gigantic beanbag chair Mom and Dad bought ME.

Family portrait:
Filip, Frank, me, Liam, and Leila.

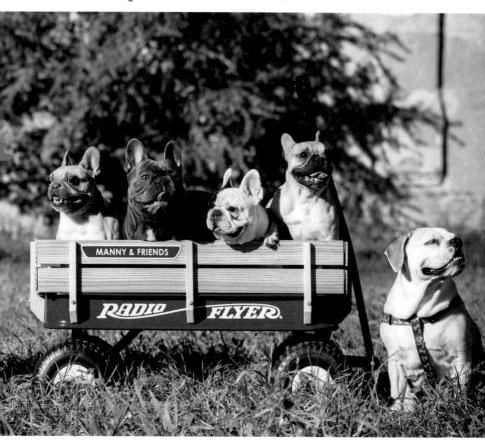

We weren't always all together. I was four months old when my mom, Amber, and my dad, Jon, adopted me. "Unsalable" was the term I remember, because I was the runt of my litter. "Runt" is such an accusatory word, don't you think? The word "shelter" was also said, and "soon." I was too young to even be scared, but I knew those words sounded *bad*.

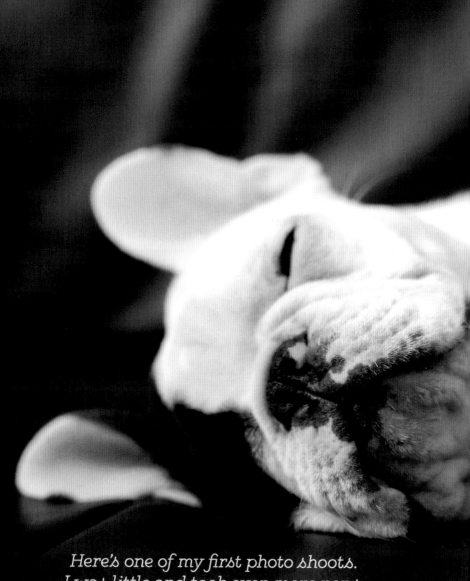

Here's one of my first photo shoots.
I was little and took even more naps
back then. Those were the days.

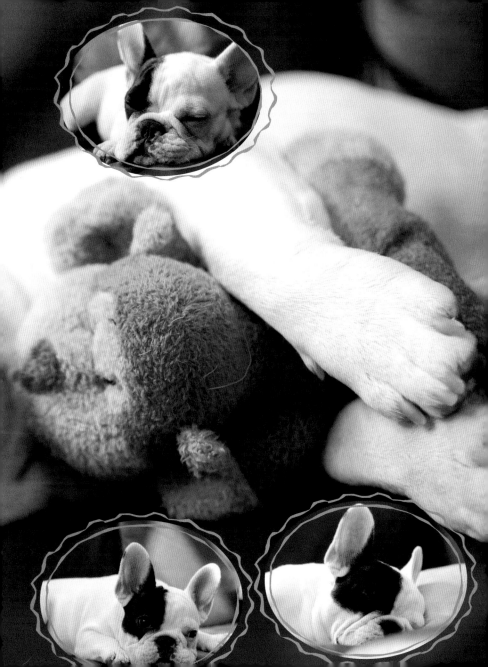

I do remember my first sight of Mom and Dad—
her beautiful warm eyes and his laughing smile.
Then she picked me up for the very first time and
we've been together ever since. Mom always says,
"I saw you, and there was no other puppy in the
room. I knew you were our Manny." I am, Mama.
Forever your pup. Rub my belly, please, and put
some muscle into it.

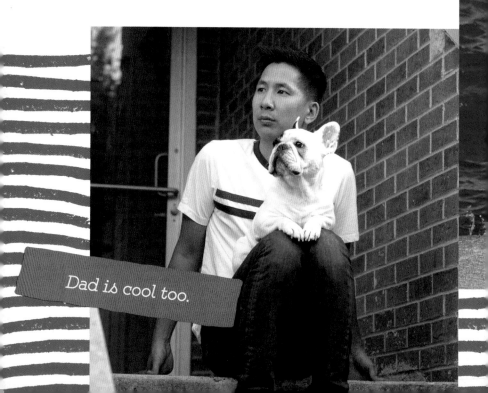

Dad is cool too.

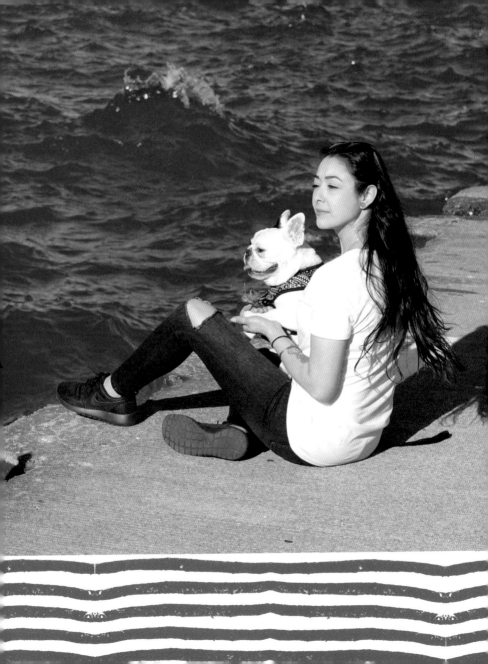

Leila

Leila

Leila

Mom and Dad are a little soft on Leila because Dad rescued her from some guy who was selling pups out of the back of a van. Can you imagine how much less happy all of our lives would be without her? It just goes to show: always check out what the guy in the back of the van is selling. Or something.

Leila is also very good at looking cute and getting extra treats—and she's not stingy about sharing. But Leila's true talent is hearing me out. She's an excellent listener and very wise, and she can always tell when Mom and Dad need a little space (we DO live in an apartment). Girl knows how to read a room. Leila hangs with Mom. BFFs.

Princess Leila

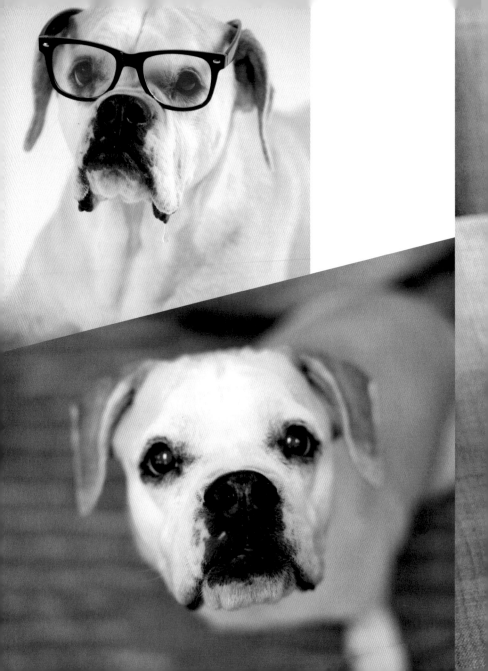

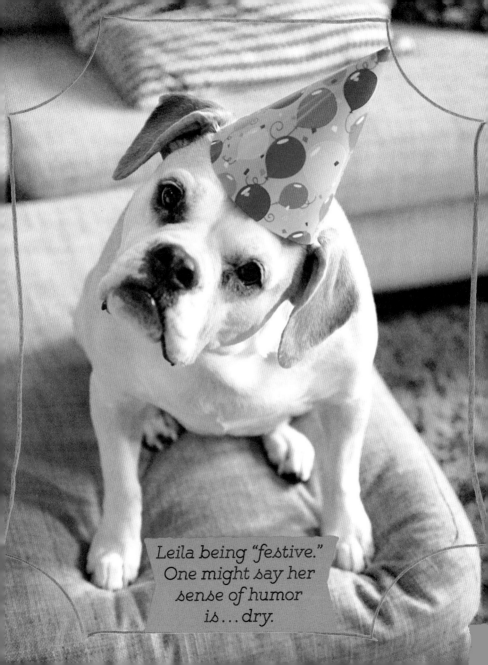

Leila being "festive."
One might say her
sense of humor
is... dry.

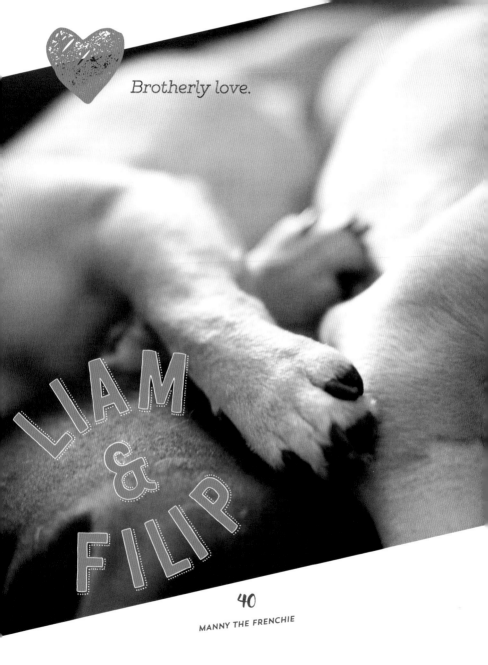

Brotherly love.

LIAM & FILIP

My little brothers Liam and Filip came into
our family, well…kind of by accident. (But that
doesn't mean we love them any less! Mom always
says that.)

Mom and Dad are simply in love with Frenchies.
Dad went to the Frenchie rescue kennel and
saw these little guys—both runts of their litters,
like me—who needed to be fostered. "Fostered" is
supposed to mean you take a dog home for a day
or two until they get their forever family.

Dad knew…once Mom, me, and the rest of the
family saw these pups and heard about their
special needs, we'd be toast with avocado and
bacon on top.

He was right. It took Mom about fifteen minutes
before she was sobbing. "I don't know how to
choose one, Jon. . . ." By the next morning, she'd
already named them. Reader, we kept them.

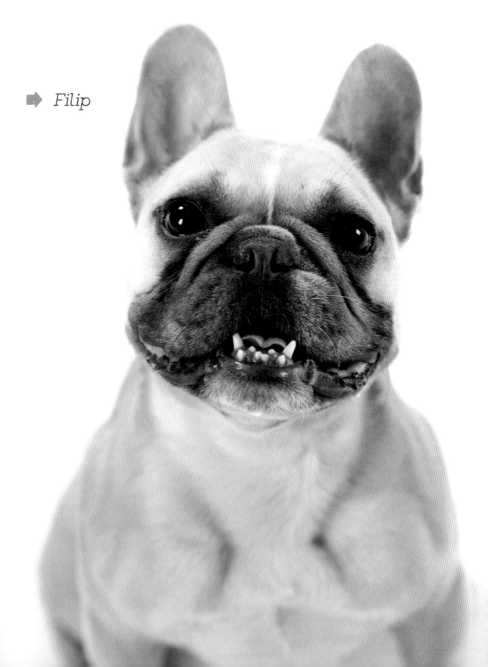
Filip

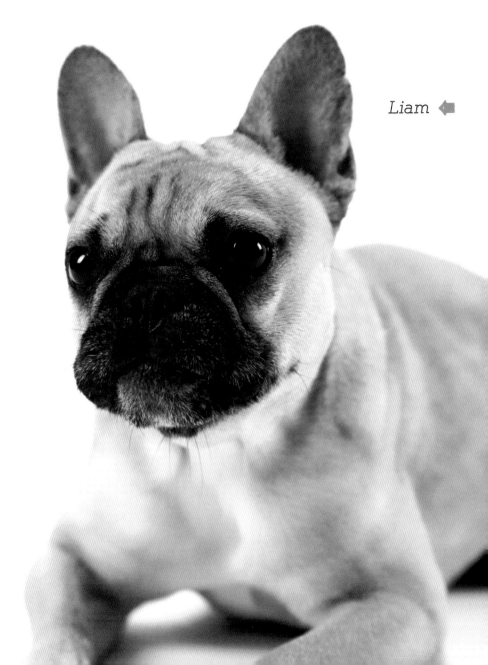
Liam

My baby bros.
I would do anything for these two.

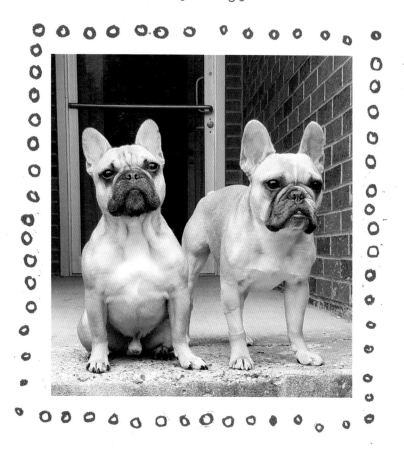

Honestly, sometimes when I'm sleep deprived (which is rare, let's face it), I mix them up. #bullytwinsies

Liam was born with an open fontanel—a soft spot on the top of his head that will never close. He's a bit feisty. He'll bark at a squirrel that he's never even met. Mom says he's trying to make up for being so little. Well, I think he's just adorable and will snuggle with him any chance I get.

Frank feels the same way about Filip. Filip has a cleft palate. This means that sometimes he has trouble keeping his food down, and we need to watch him for breathing troubles.

They're both doing great now, but we all have to be careful about roughhousing too much with them. That's no problem, because they're our babies!

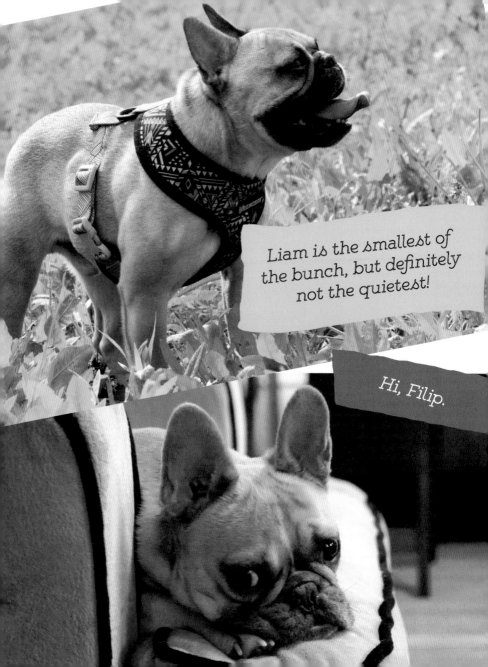

Liam is the smallest of the bunch, but definitely not the quietest!

Hi, Filip.

If I didn't have my brothers and my sister, Leila, what would I do when I wasn't napping? Who would I conspire with to get more treats? Who would snuggle me when Mom and Dad weren't home? My family is my rock—they listen, they support me, they buy the snacks…they put a smile on my face a dozens times a day. Family should be cherished. (Don't hesitate to remind me of this the next time Frank gets the bed.)

47

F★R★A★N★K

In any guide to happiness, some darkness must appear. The cloud for the silver lining, the yin to the yang, the pesky plastic packaging around the delectable treat of life.

In my case, that plastic packaging has a name: Frank.

The first time we met, we touched noses, sniffed butts. When he licked food off the floor, I thought, Well, okay, everyone likes food. Then it got personal. My food, my bed, my couch, my mom, my dad. You'd think Frank was going to get everything! Then we fell asleep, and everyone said we were sooooooo cute. I guess we were, but that was before Frank decided what was mine was his. As in bed, treats, everything.

Copycat.

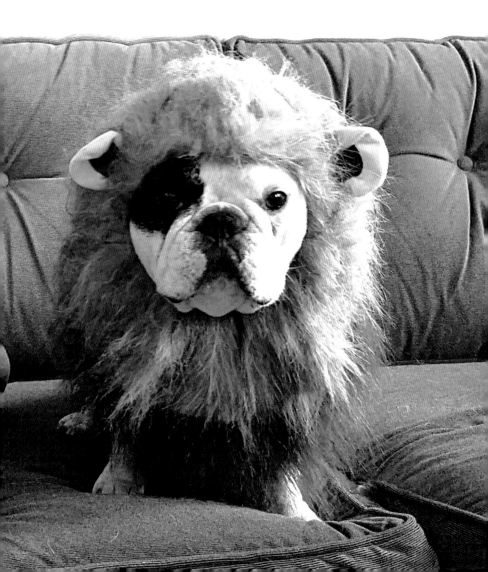

Okay, maybe I'm being a *bit* harsh. I was a little tired or hungry or something when I wrote that last bit. Maybe even *hangry.* After some treats and a little nap next to Frank, I softened. If Frank was drowning and the water was not too deep and I was a *better* swimmer (I am a Frenchie, after all), I would save him. If an angry sheepdog—or sheep!— were chasing Frank, I would *whinny* and *arroo* in Frenchie talk until that bad sheep-whatever got distracted and went on home. If Frank and I were alone on a desert island with no food, I'd snuggle up and nap with him before even thinking about eating him (and I would probably eat a palm tree first, because Frank probably wouldn't taste very good). Life without Frank would be...dull, I admit it.

Reader, I urge you to search for the best in your fellow humans and dog friends, enjoy them, and you will be rewarded.

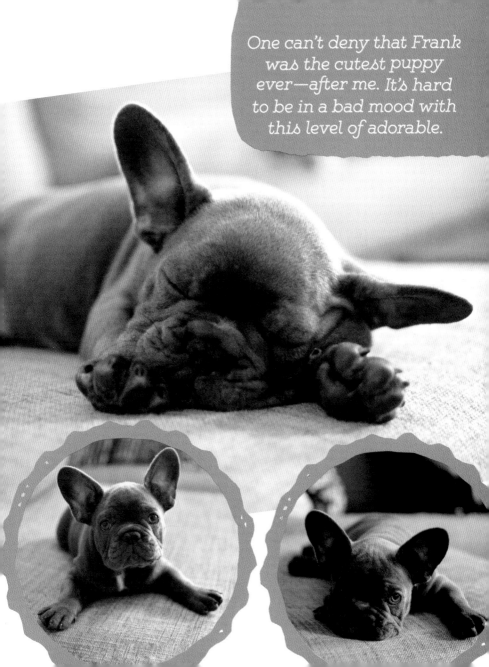

One can't deny that Frank was the cutest puppy ever—after me. It's hard to be in a bad mood with this level of adorable.

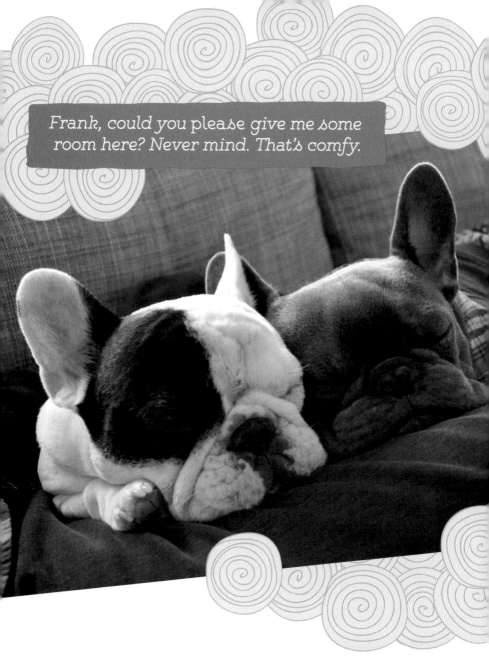

Frank, could you please give me some room here? Never mind. That's comfy.

Bros who nap together, stay together.

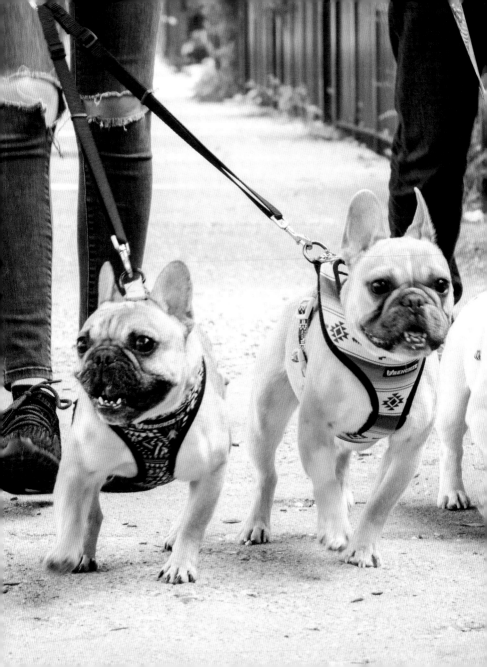

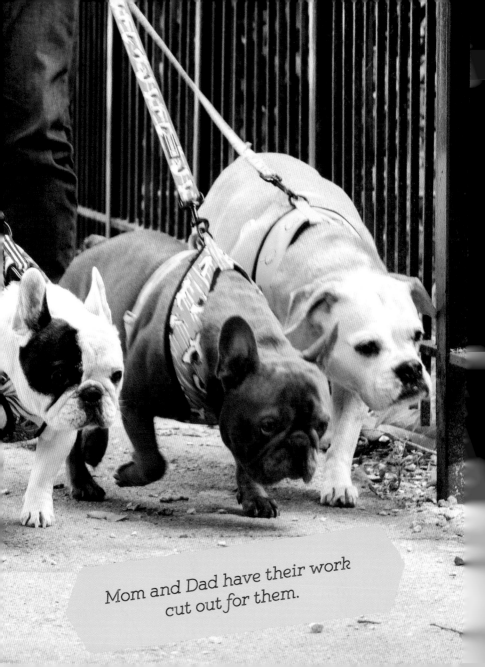

Mom and Dad have their work cut out for them.

A NOTE FROM FRANK

Dear Reader,

*Frank here. I feel compelled to set the record straight. Manny is my big brother, and I love him. However, he sometimes, shall we say, **dominates the discussion**, especially as it pertains to our relationship and to me.*

When Mom and Dad adopted me, I was just a pup: small, charcoal gray, elegant. Manny took me under his paw, showed me how to hop on the couch, jump high for treats, and where all the best shady corners of our condo were on hot afternoons. We puppy-piled during naptime and even shared toys.

Then I grew. Mom and Dad would be so surprised. "You look like you got bigger overnight, Frankie Boy," they'd say. I was proud of my increasing size and girth. A dog likes to feel solid in the world.

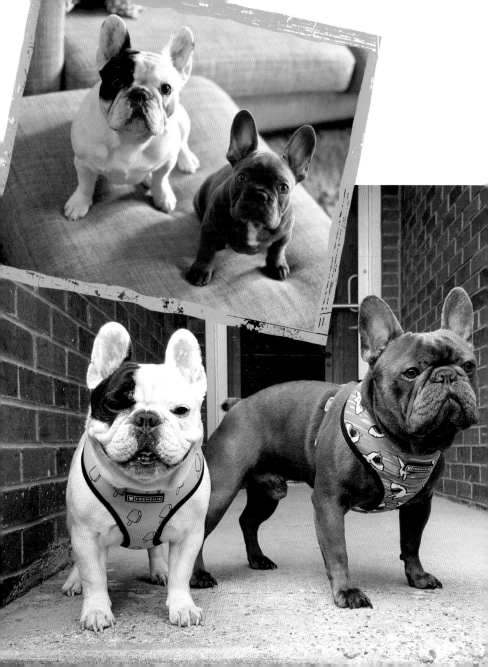

Eventually, though, I grew bigger than Manny. Then visitors would comment, "Looks like Frank wasn't the runt of his litter!" Please note: I would never say such a thing. Manny was the runt, and I respect his sensitivities. Nevertheless, you know how people are. I began to get extra treats because I was growing, and I started to edge Manny out of the dog bed at night. It wasn't ever on purpose. I swear.

Here I rest my case (and my elegantly shaped head). Please enjoy the rest of this guide. I remain, as always, your devoted,

Frank

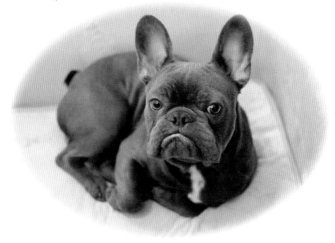

Hiding from
Frank

shhh ...

CHAPTER

4

STYLE

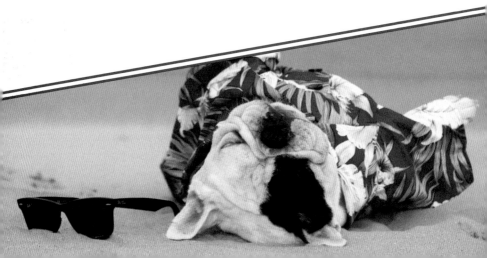

WHAT IT TAKES TO BE A FRENCHINISTA!

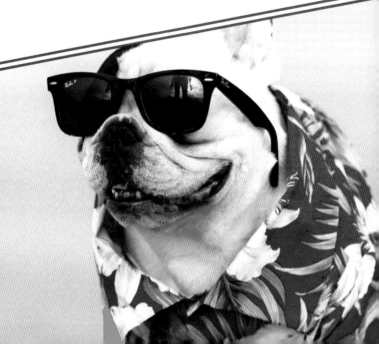

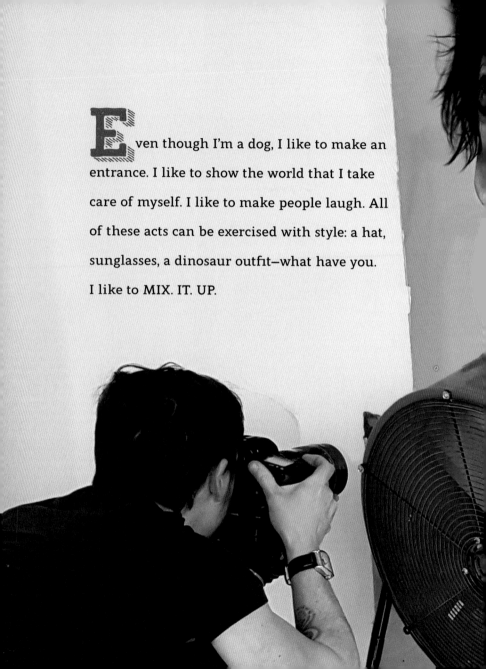

Even though I'm a dog, I like to make an entrance. I like to show the world that I take care of myself. I like to make people laugh. All of these acts can be exercised with style: a hat, sunglasses, a dinosaur outfit—what have you. I like to MIX. IT. UP.

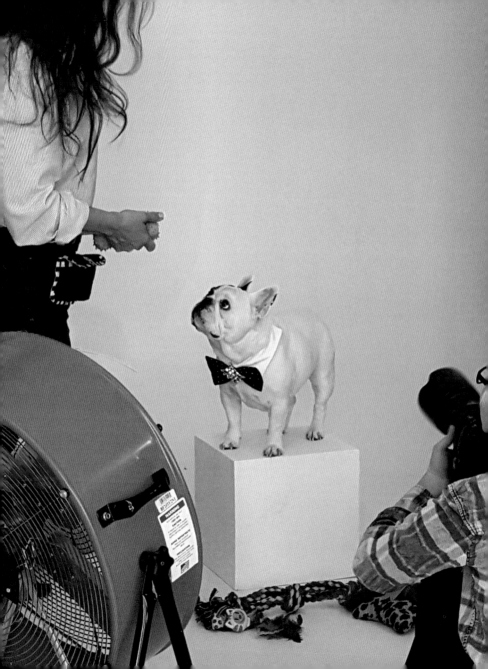

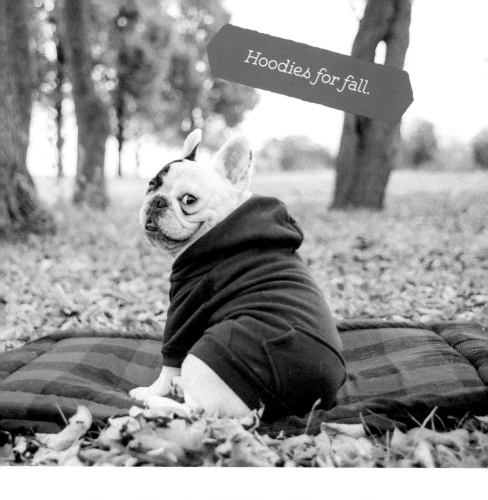

Hoodies for fall.

The world needs a little flair, and bringing that flair gives me joy. The important thing is to be comfortable in your own skin and show the world what you got.

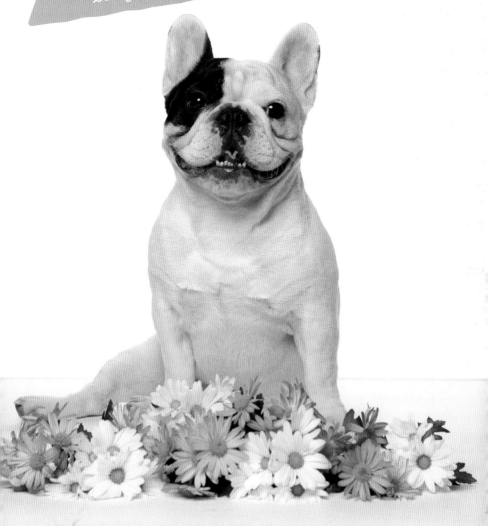

Florals and my birthday suit for spring!

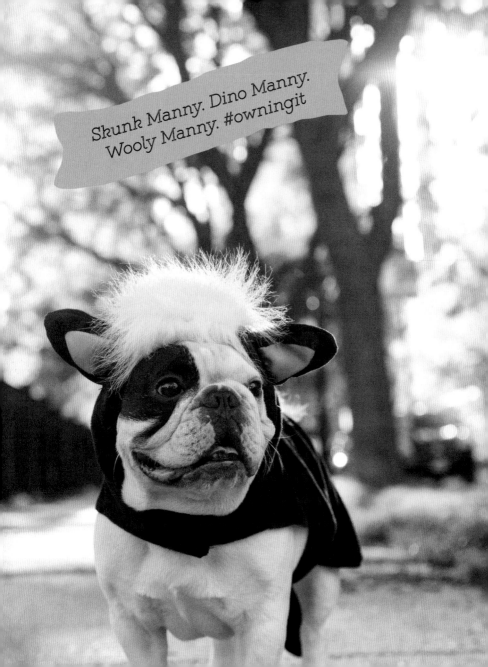

Skunk Manny. Dino Manny.
Wooly Manny. #owningit

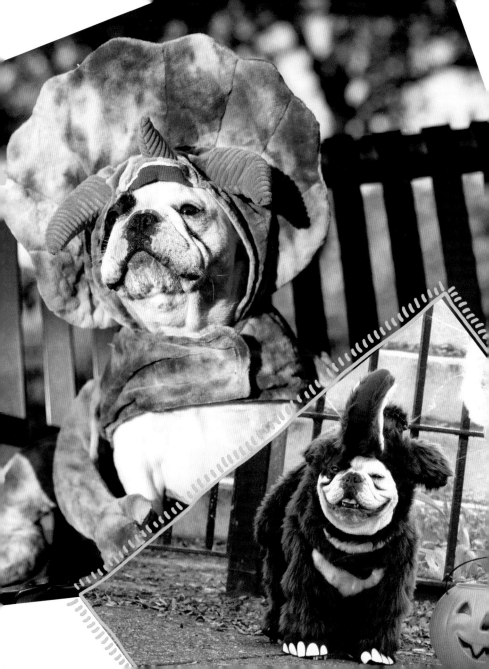

What am I? Do you have any idea?

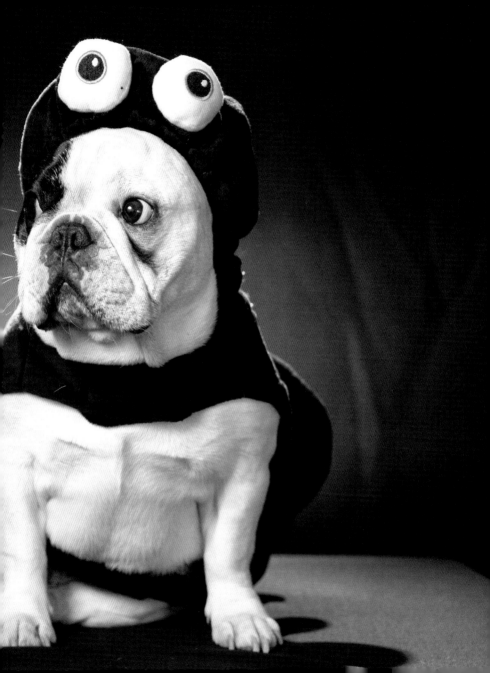

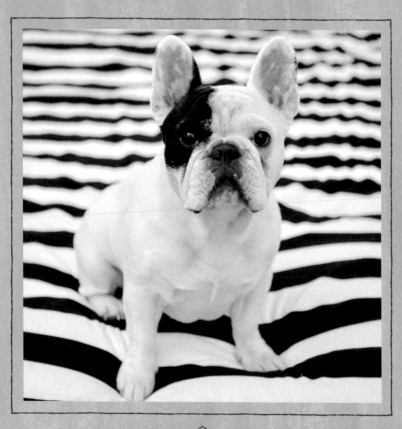

Lounging
in style.

74

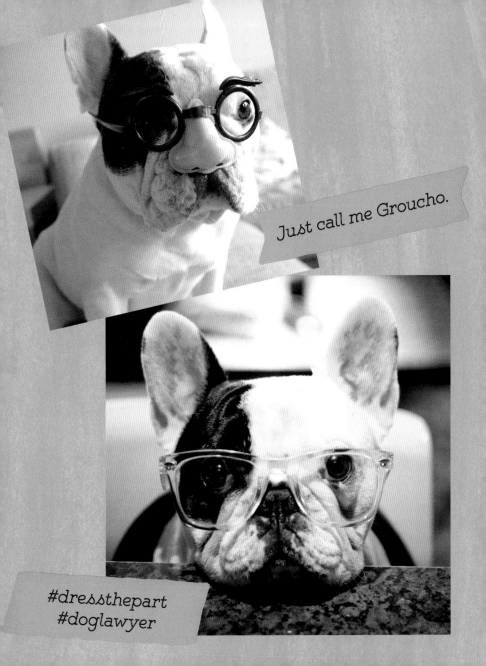

Just call me Groucho.

#dressthepart
#doglawyer

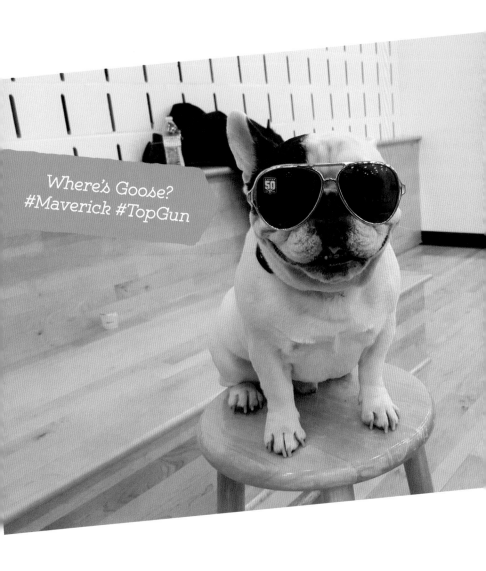

Where's Goose?
#Maverick #TopGun

MANNY THE FRENCHIE

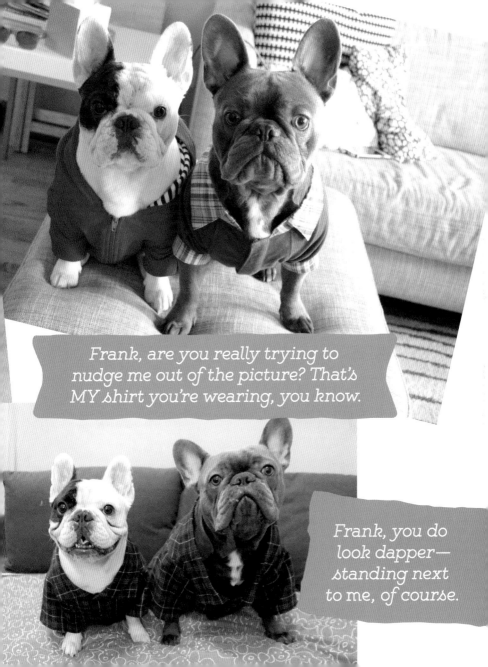

TAKE IT EASY
WHEN YOU CAN

Seven ways to de-stress when it's all just "too much":

1. Nap.

2. Go out and help a friend.

3. Hang with Leila, who always has wise words—she's a survivor.

4. Try a napping location that's never been tried before (gets me out of my head).

5. Flirt for treats.

6. Maybe do a little yoga. Favorite positions: lying on back, child's pose.

7. You guessed it. Nap.

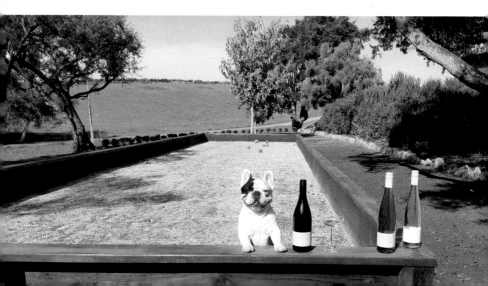

A little boce, a little vino, a
little sunbathing...#metime

A Midsummer Night's Manny?
Are you feeling it?

FOOD

(WAIT,
WHY ISN'T THIS
CHAPTER 1?
WHAT TOOK US
SO LONG
TO GET HERE?)

This is the big one. FOOD. I could argue that love of the chompy stuff is the driving force behind all dog behavior. Food—quantity AND quality—is also the secret to smooth relations between pups and other pups, pups and humans, and everyone and everyone. No one likes another dog's nose in his bowl. (Ya hear me, FRANK?)

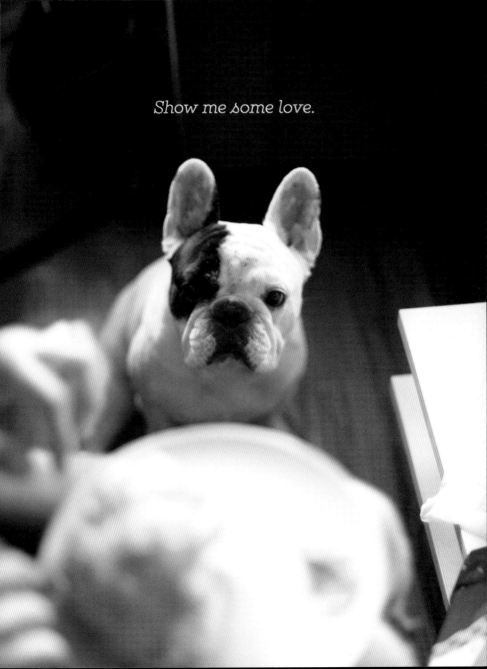

Show me some love.

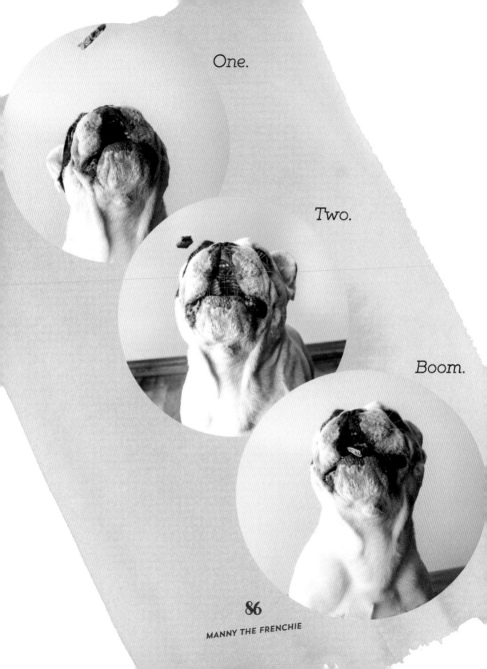

One.

Two.

Boom.

Us French bulldogs need to watch it, though, because if we get too chubby, we go…spherical. It's not good. So while staying lean and healthy is a bit dull, I feel compelled to blah blah ask your doctor before starting any new diet or weight-loss scheme whatever.

Now on to the good stuff!

So there are meals and then there are treats. The number of meals per day doesn't change, but the number of treats?! Oh baby. That's something where you can really set some records. And the thing is, Mom and Dad know that I will accept treats as rewards for behavior! Like, they should have just started out by giving me a pat on the head or a high five or something, because then I wouldn't hope for the Snausages (I saw an ad for them once and Mom said they were junk food, but COME ON) every time I winked.

Giving those you love food, even sharing (sometimes) is a way of showing love. When Mom or Dad tops up my morning bowl of oatmeal-with-stuff-in-it, and I get that smile and the "Here you go, Manny Boy" and the pat on the head, I feel so…taken care of, almost snuggled. And then when I dig my face into that delicious bowl…it's love for sure.

My regular diet is pretty reliable: oatmeal-with-stuff-in-it, oatmeal-with-stuff-in-it, twice a day, every day. Sometimes, though, I get to experiment or even go out with Mom and Dad and the fam. I'm happy curled up under a café table with a bowl of fresh water just about anywhere….

Brunch in Wicker Park. THE BEST.

This is a super-hip neighborhood. My whole family loves to go here when the weather's nice. Mom and Dad love all the shops and the coffee. I'd like a water bowl under their table, please.

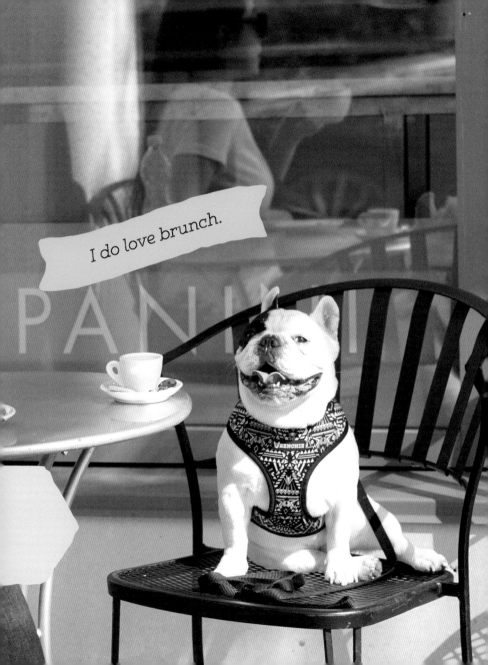

I do love brunch.

That's more like it. I'll take a dog,
Chicago style, please.
I looove summer in the city.

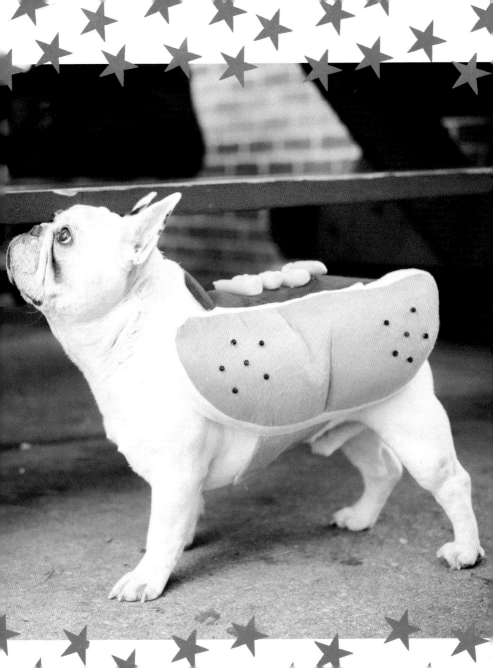

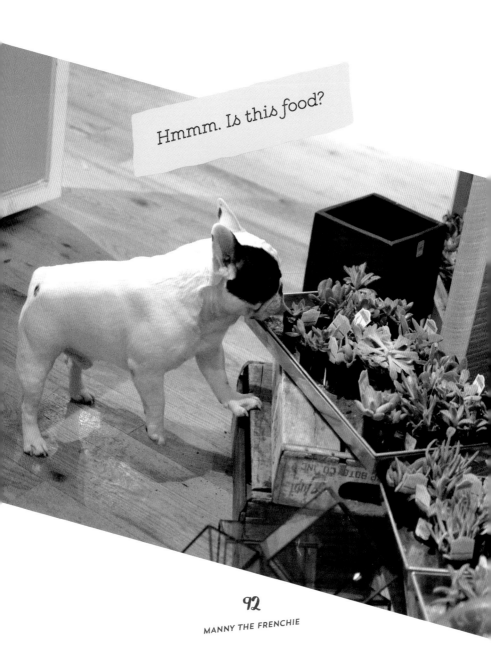

Hmmm. Is this food?

PUBLIC SERVICE
ANNOUNCEMENT

Please avoid giving dogs the following human foods for the sake of their health and happiness (courtesy of the ASPCA):

Alcohol

Avocado

Chocolate, coffee, and caffeine

Citrus

Macadamia nuts

Milk and dairy

Onions, garlic, and chives

Raw/undercooked meats, eggs, and bones

Salt and salty snack foods

93

CHAPTER

6

ADVENTURE

HAVE YOU EVER SEEN A FLYING FRENCHIE?!

A typical schedule for my siblings and me living the happiest life: We wake up with Mom and Dad at around eight thirty or nine, though we all love to sleep in on the weekends. Breakfast is the aforementioned oatmeal-with-stuff-in-it, and then we nap and have a refreshing treat. Then we get leashed up for a trip to the dog park (weather permitting), followed by more treats, another nap, playtime, nap, treats, dinner. Perfection, right?

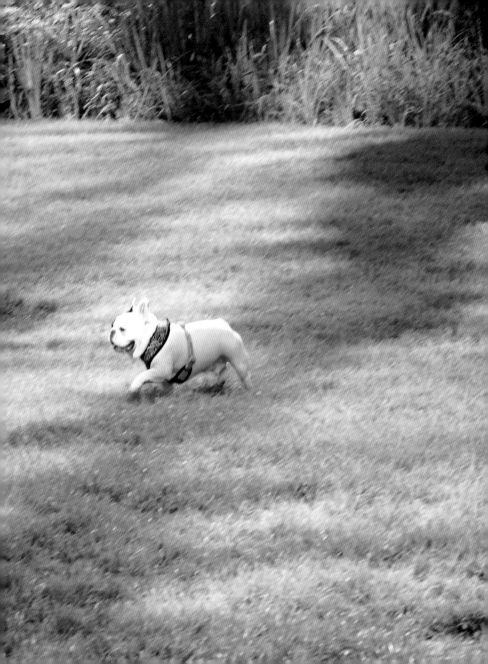

As demonstrated by my love of sleeping in the sink and hanging with my crew, one might argue that there's really no reason to leave the house. (Especially if the cupboards are stocked.) As appealing as napping full-time may seem, one must see the world, nourish the soul, and push those boundaries. Seeking adventure is how you find out what you're truly capable of.

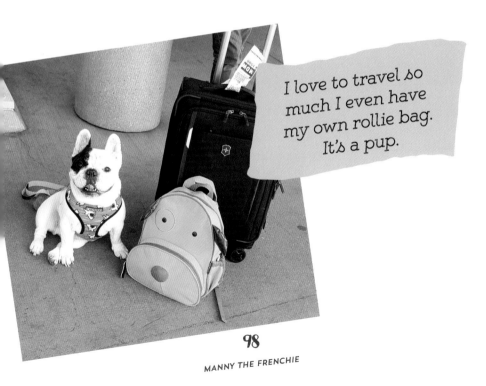

I love to travel so much I even have my own rollie bag. It's a pup.

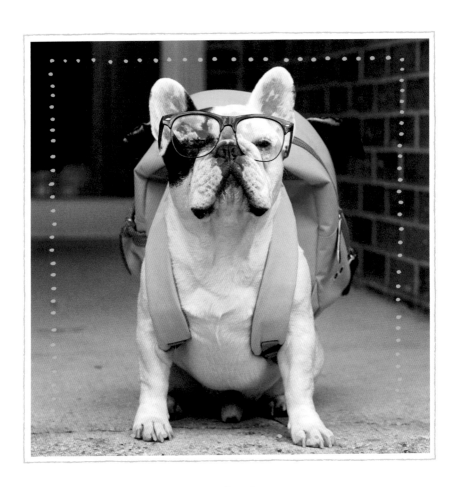

Let's do this.

99

ADVENTURE

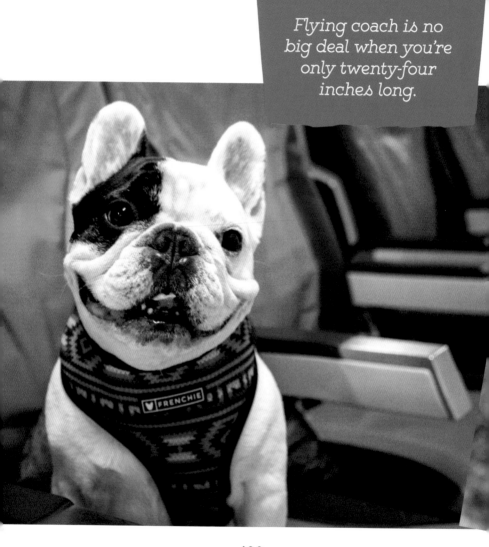

Flying coach is no big deal when you're only twenty-four inches long.

100

MannyBjörn.

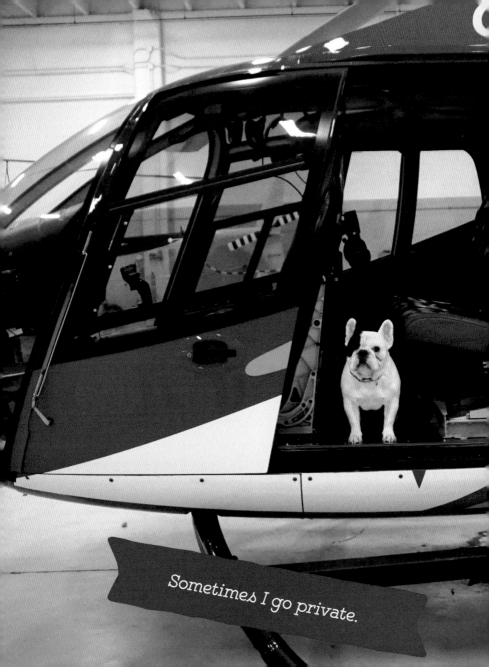

Sometimes I go private.

Where to next?

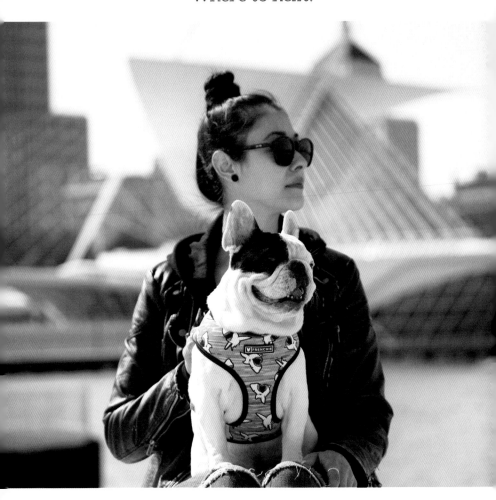

MANNY THE FRENCHIE

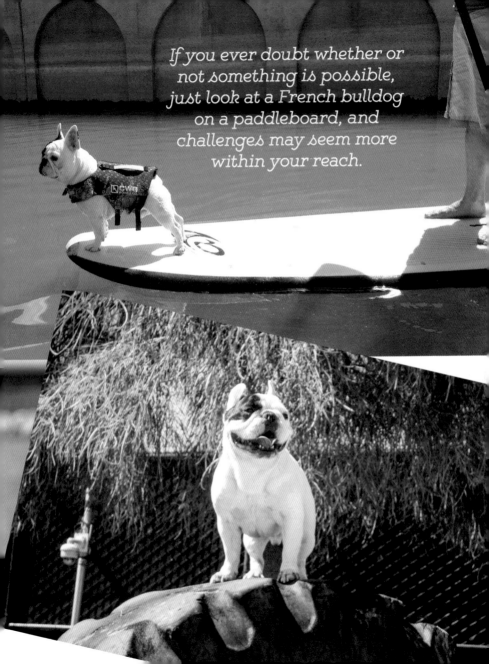

If you ever doubt whether or not something is possible, just look at a French bulldog on a paddleboard, and challenges may seem more within your reach.

See the sights;
find inner peace.

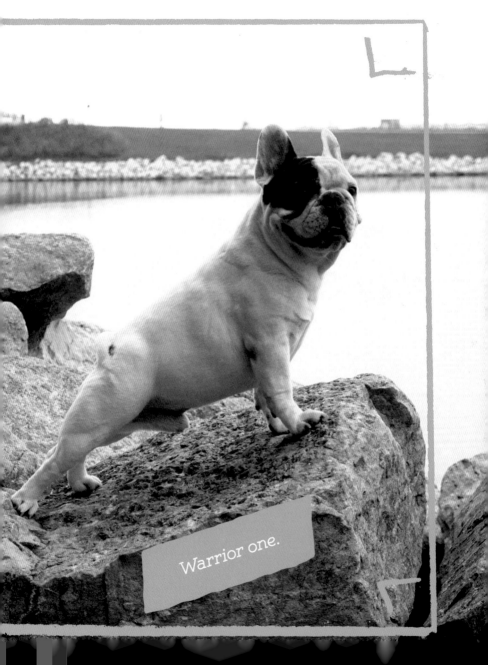

Warrior one.

Wine country.
Gorgeous.

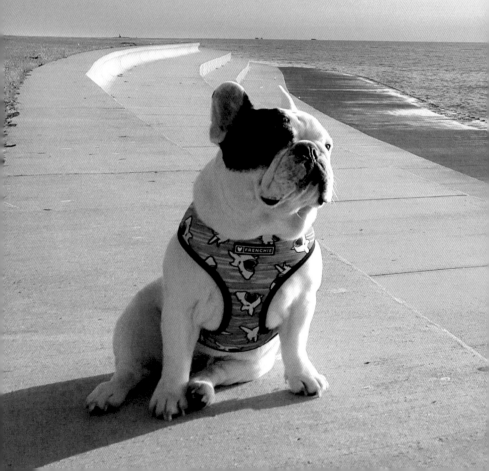

MANNY'S
TOP HANGOUTS FOR
WINDY CITY DOGS

In general, Chicagoans love dogs. Whenever there's the opportunity for a little off-leash playing, or an extra bone or two at a local restaurant, you'll see all breeds and sizes hanging out. Here are a few of my favorite spots:

Walking on the Lakefront Trail

The best skyline.

The Montrose Dog Beach on Lake Michigan

This is a real off-leash dog beach!

Anything in Grant Park

The leash rules can be strict, but all the coolest events happen here. Lollapalooza (which I got to attend!) and even Obama's speech when he won the election in 2008. They have this amazing food festival called Taste of Chicago there every summer. So many sausages…

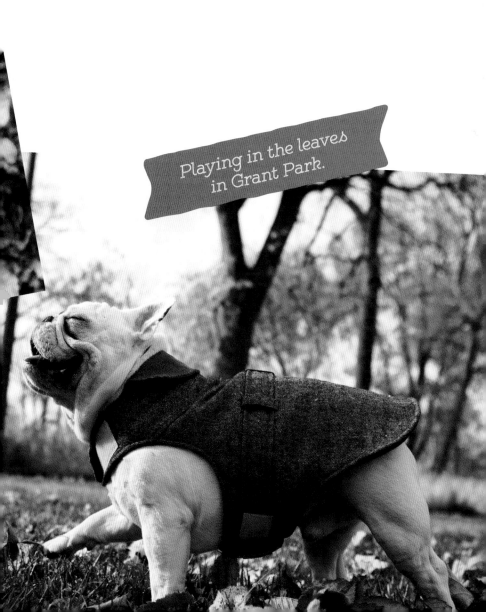

Playing in the leaves
in Grant Park.

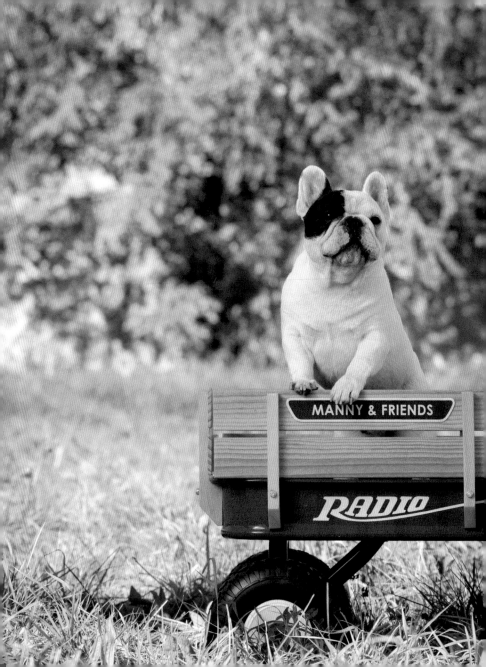

MY BFFs

BEST FRENCHIES
FOREVER

I'm lucky enough to have made a lot of very cool dog FRIENDS.

Other than great laughs and just sheer fun, my friends are an amazing support system in work, in life, and in treat strategizing. You name it.

Sir Charles Barkley (what a name, RIGHT?!) is a true bestie. He can get a little competitive on the treat front. Okay, make that VERY competitive. He's shameless, but he's always there for me. He's like my brother from another mother, you know?

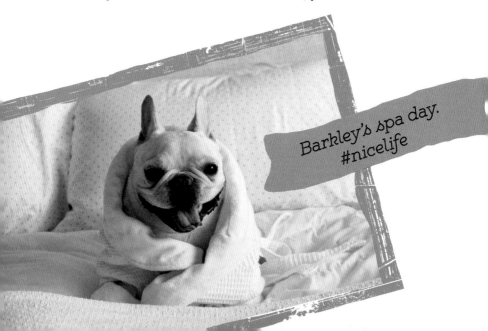

Barkley's spa day.
#nicelife

Sir Charles Barkley

Nice shirt.
My fashion sense
has rubbed off on
him, clearly.

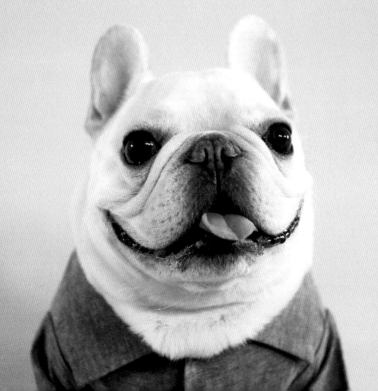

Cooper

Then there's my man Cooper.

We came from the same breeder so we have that extra-special bond. I think we might even be cousins. There's certainly a resemblance.

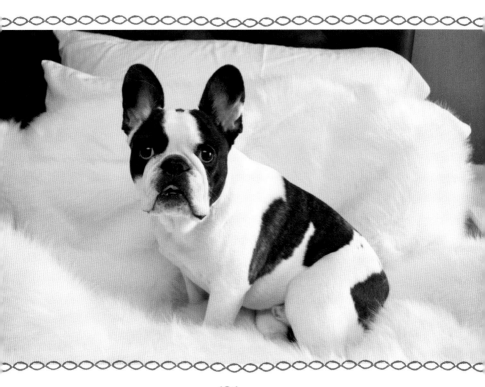

MY BFFs

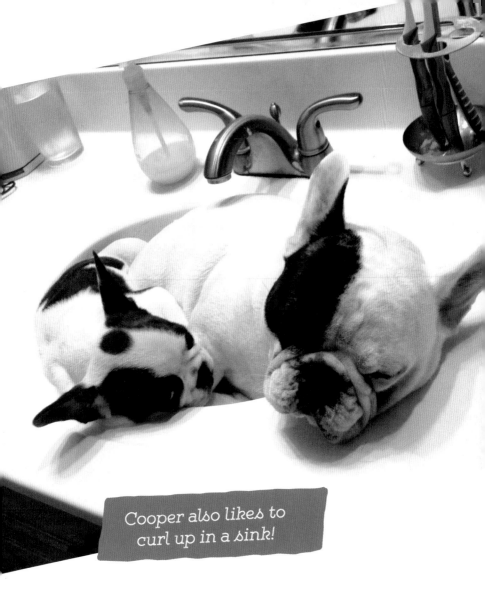

Cooper also likes to curl up in a sink!

122

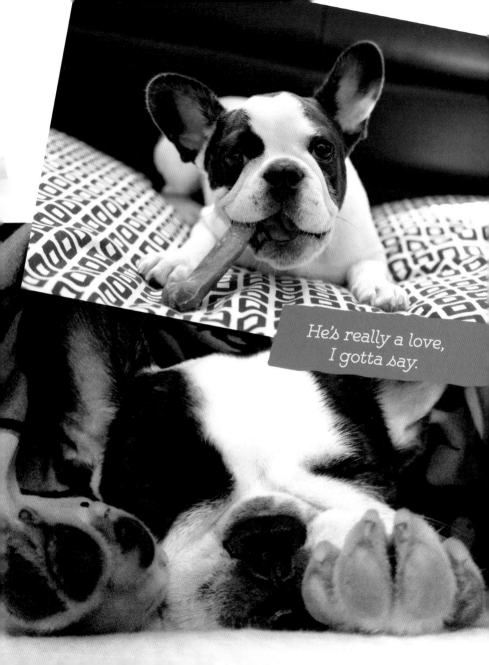

He's really a love,
I gotta say.

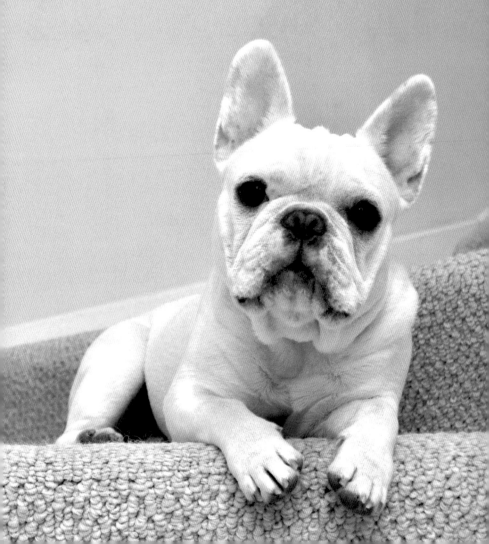

Fredrick

Next, meet Fredrick.

I have a real soft spot for this blondie. Even though he was rescued from a puppy mill (really, one of the worst places to be born), Fredrick is the most positive and inspiring guy. He just doesn't see the use in letting the world get you down. Which reminds me again and again that we all can CHOOSE happiness.

Check out puppy Fredrick.

I dare you not to adopt a Frenchie after reading this book. #frenchiefever

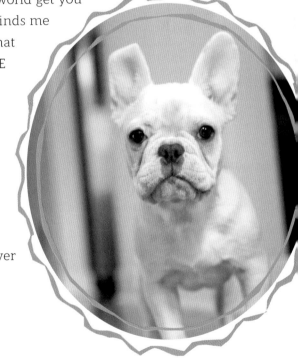

He's also tight with Cooper....

They have a similar relationship to mine and
Frank's. Competitive with snuggles.

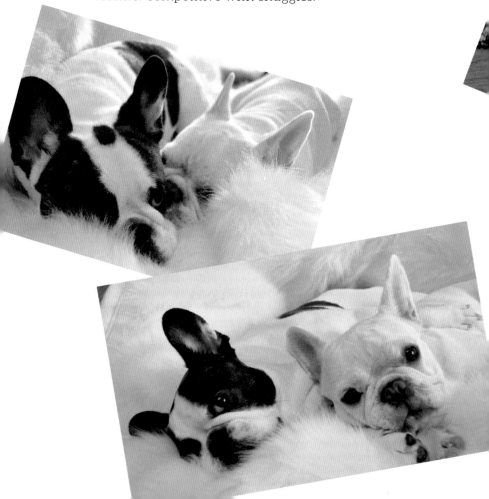

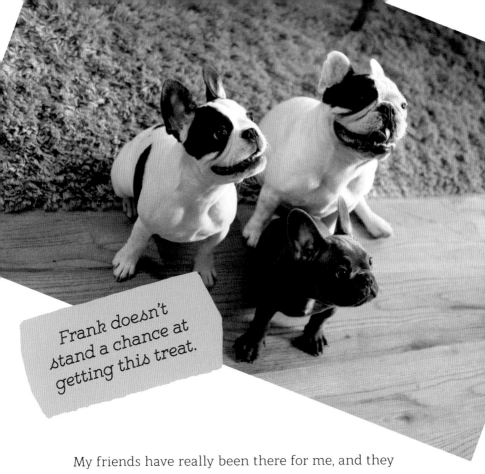

Frank doesn't stand a chance at getting this treat.

My friends have really been there for me, and they also fuel me every day with inspiration. They are committed to giving back and helping other dogs and humans. It's like a philanthro-pup posse, and I'm grateful for them. Happiness is doing what you love with the dogs and people you love.

127

BACON

(AKA THE SIXTH FOOD GROUP)

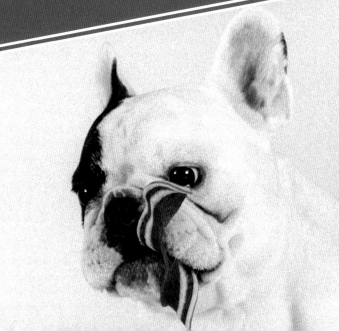

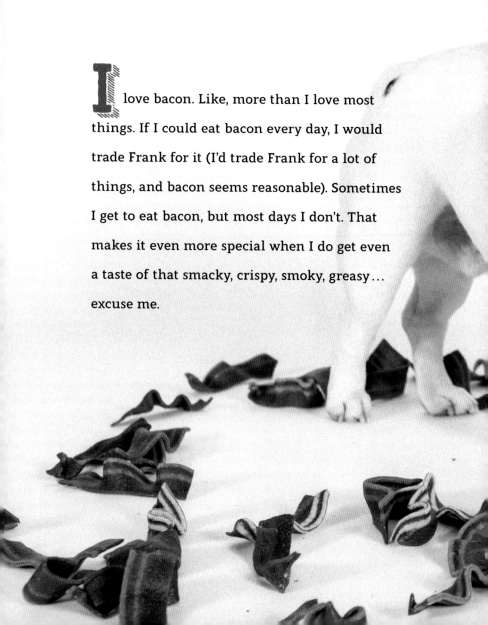

I love bacon. Like, more than I love most things. If I could eat bacon every day, I would trade Frank for it (I'd trade Frank for a lot of things, and bacon seems reasonable). Sometimes I get to eat bacon, but most days I don't. That makes it even more special when I do get even a taste of that smacky, crispy, smoky, greasy... excuse me.

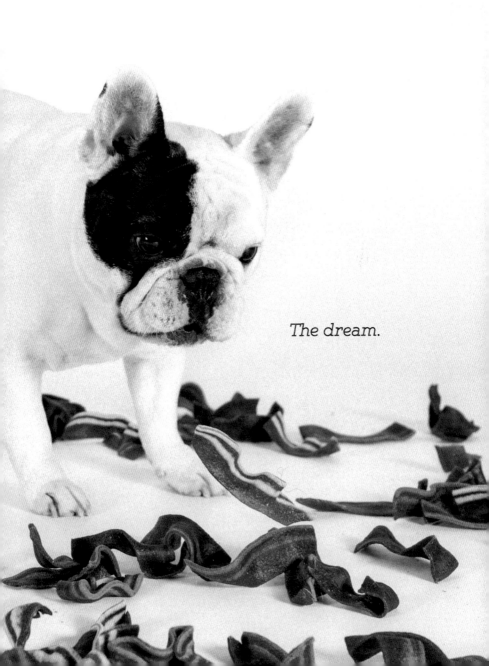

The dream.

Okay. Most days I don't get bacon. Not only because it's special, but because it actually makes me kind of sick if I eat more than a bite (I won't go into detail—use your imagination). I do, however, get treats every day, often bacon *flavored*. You know what? They're delicious. I'll take 'em! Sometimes I have to remind myself that every day is not a party, and that's actually for the best. This is where my maturity comes into play: life balance will lead to happiness. Sigh.

Now this doesn't mean I don't dream of bacon. In fact, many nights, my dreams look something like…this…

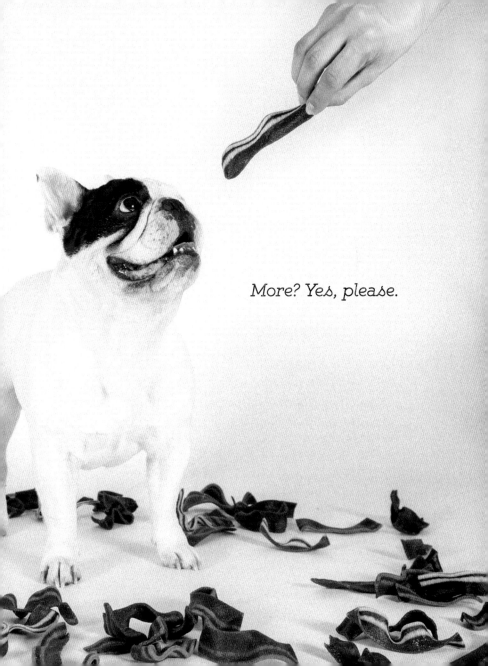

More? Yes, please.

MANNY'S FAVORITE FILMS

When Mom and Dad go out they like to leave the TV on so us pups get some extra entertainment. Though Mom prefers the Disney Channel (really, I am like thirty-five in dog years!), every now and then we've managed to sneak peeks at some less obvious classics that have become faves:

101 Dalmatians This is a family favorite for obvious reasons. We just can't watch the newer, live-action version. It's cute and all, but that Glenn Close as Cruella De Vil gives Leila the fireworks shakes.

Shaun the Sheep This is a new flick by the brilliant animators who also did another fave, **Wallace & Gromit**. I mean, it is so cool. The dog always saves the day with these guys! And those sheep are freaking hilarious when they dress up in clothes.

An Affair to Remember Another classic. I don't know why, but I SOB through it. Will they or won't they get together? Deborah Kerr reminds me of Mom with her smile. Pass the Kleenex. Unless you're FRANK and made of stone, apparently.

Legally Blonde Okay, this one is sort of a guilty pleasure. It's Leila's fave. She likes that the girl seems spacey but turns out to save the day. And there's a great (but very pampered) pup.

Snoopy Come Home That Snoopy. Isn't he just the best dog? It's kind of like **An Affair to Remember**, except about Snoopy and Charlie Brown, and will Snoopy stay with Charlie or will he go off with that little sick girl who used to own him? Oh, boy. More Kleenex.

Groundhog Day Mom and Dad always say this movie is hilarious. They laugh and laugh, but I don't see why. Life is perfect in **Groundhog Day**. Every day is the same—who cares? Isn't that the point? I got you, babe.

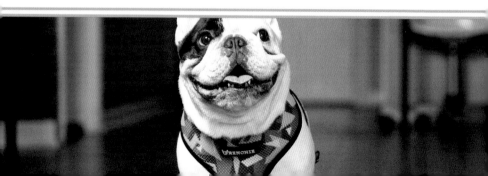

GIVING

BACK

MANNY,
THE
PHILANTHRO-PUP,
AT
YOUR SERVICE

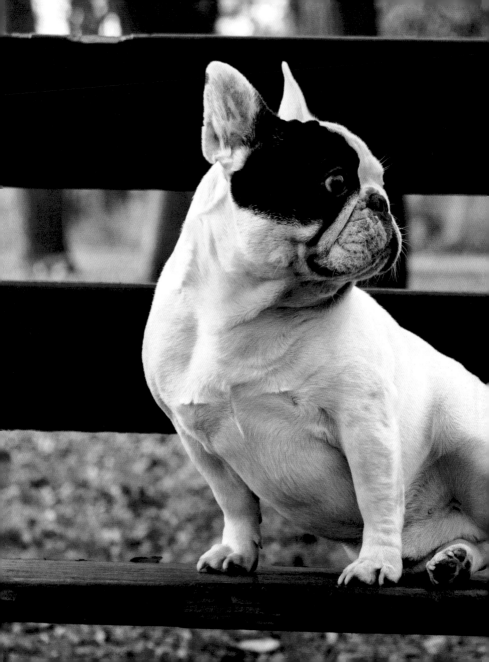

Meeting so many new dogs and people and traveling for events is super fun. But I don't know. Sometimes you just want more, somehow.

I got a great idea one day when I was licking Filip's adorable head. That pup, I kept thinking, if he hadn't been rescued, well, maybe he would have been (I don't even want to say it…). Mom was always talking about "rescue" this and "rescue" that. So I decided maybe, if so many people liked *me* and my siblings so much, maybe we could help more Frenchies and even other breeds get forever homes as loving and special as my house. Maybe they could go on the Internet and eventually I could even meet them. More friends!

I guess Mom and Dad had been thinking the same thing (it's called canine-human ESP), because one day they told me we were going to do a special "event." People would come, take photos with me, and even bring their own dogs. We'd raise money for pups without homes. Well, it went great.

After that, it was like I got a taste for it. I wanted to do event, event, event. When I saw Mom pull my travel box out of the closet, or if Dad told me he had an "itinerary," I'd get so excited, my stump would wag and wag.

Since then, I've raised more than $100,000 for my charity, Manny and Friends.

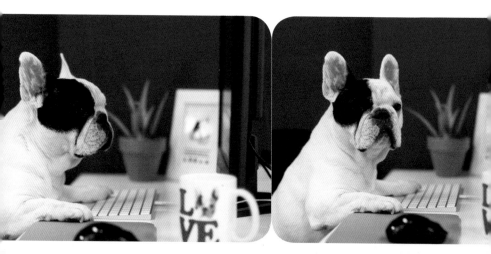

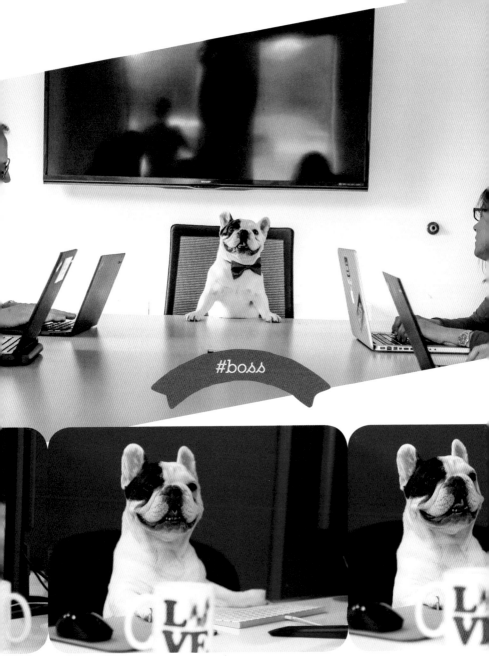
#boss

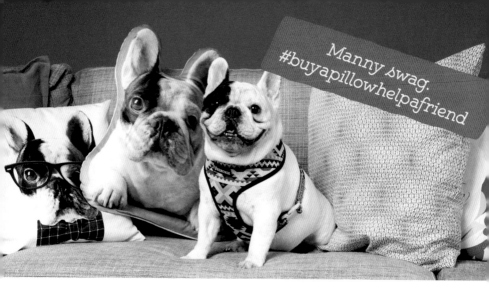

Manny swag: #buyapillowhelpafriend

I'm lucky. So many dogs—and people—don't get to do what they think they're best at every day. It's different for me. I started out posing for my little photos, and then suddenly that wasn't just my hobby, it was my job. Then I thought it would be cool to help other Frenchies who didn't have the same family and opportunities as I do, and before I knew it, that was a job too. It's all pretty—and I'm about to use a five-bone word here—fortuitous. But also not. If you can live life like a dog would, you'll find it's not a ruff way to be. Happiness is just a nap away.

MY *favorite* GIVING-BACK MOMENTS

🐾 Traveling all the way to Mississippi to hang out with
a wonderful girl with cystic fibrosis and putting a big
smile on her face: priceless.

🐾 Bringing a Dodge Caravan to Chicago's French Bulldog
Rescue. Those dudes needed wheels to help other dudes.

🐾 Supplying my local vet's office with the peaceful,
meditative qualities of an aquarium in their lobby.
If you're getting your nails clipped, this helps.

Hello again, Reader,

So here I am. Me, Manny. As I finish this book, I realize I am five years old—that's thirty-five in dog years, the prime of my life. Along the way, I've really concentrated on my vision of what it means to be happy. My conclusion? The formula for living a happy life for sure includes travel, imaginary bacon, and reaching out to make the world a better place. But really, the main ingredients for happiness are what we all can find in the first place we look: at home with my family, my food bowl, and (most of all) plenty of time to sleep. And watching Snoopy Come Home.

Even the best snack-tree in the world is meaningless without the people and animals I—we all—love. Find your pack, reader, those souls you love most of all. When you've found them, pile up with them, breathe deep, and take a good long nap. And hold your mom's hand once in a while. She won't mind a bit.

Your friend,

Manny

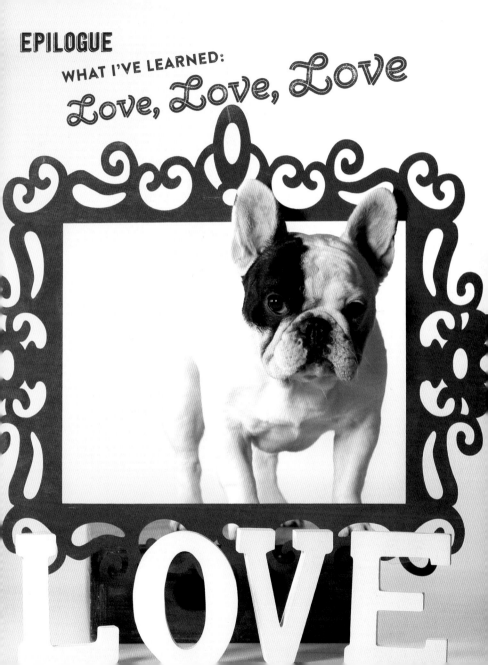

EPILOGUE

WHAT I'VE LEARNED:
Love, Love, Love

LOVE

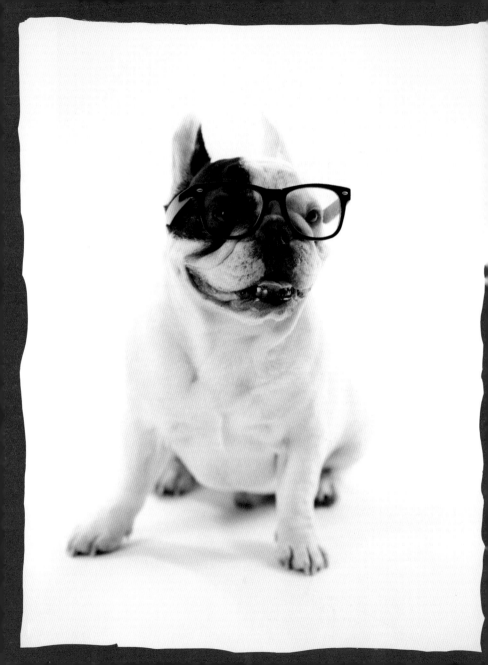

My Favorite Charities

This is serious business, folks. I'm all about giving back. Here are some of my favorite organizations. I urge you to reach out and do what you can. Peace!

Cystic Fibrosis Foundation

www.cff.org
info@cff.org
6931 Arlington Road
2nd Floor
Bethesda, MD 20814
#301-951-4422
#800-FIGHT-CF (344-4823), toll free

St. Jude's

www.stjude.org
262 Danny Thomas Place
Memphis, TN 38105
#800-822-6344 Donor services
#800-805-5856 Donate by phone

Chicago French Bulldog Rescue

www.frenchieporvous.org
Mary@frenchieporvous.org to surrender a French bulldog
201 W. Lake St. Suite #118
Chicago, IL 60612

Best Friends Animal Society

www.bestfriends.org
info@bestfriends.org
donations@bestfriends.org
5001 Angel Canyon Road
Kanab, UT 84741
#435-644-2001

ASPCA

www.aspca.org
publicinformation@aspca.org
424 E. 92nd St.
New York, NY 10128
#212-876-7700
#888-666-2279 General info, toll free
#800-628-0028 Donations
#212-876-7700, ext 4120 Adoption Center

Acknowledgments

Thank you to Elizabeth Isadora Gold and all my humans who made this book possible (because let's get real, dogs don't have thumbs, which makes it very difficult to type!). Thank you to my agent, Nicole James at Chalberg & Sussman, for her authorial guidance and bulldog obsession. Thank you to my brilliant editor, Lauren Spiegel, for believing in me, and to Shawn Dahl for her amazing design. Thanks to all the folks at Touchstone for their hard work: Jessie Chasan-Taber, Meredith Vilarello, Jessica Roth, and Charlotte O'Donnell.

A big shout-out to all the pup-arazzi for all the photos, and thank you to my pals Cooper, Fredrick, Sir Charles Barkley, and my sisters and brothers for being featured in this book. You all are my rock.

Most of all, thank you to my mom and dad, Amber Chavez and Jon Huang, for rescuing me when I was a pup, for allowing me to live the dream, and for never letting a day go by without treats.

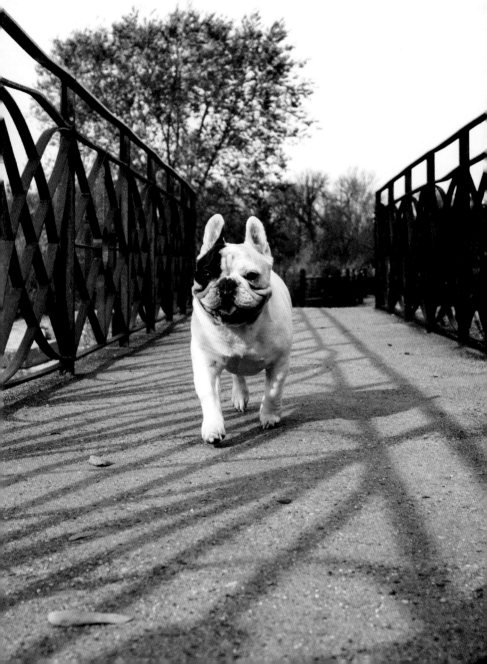

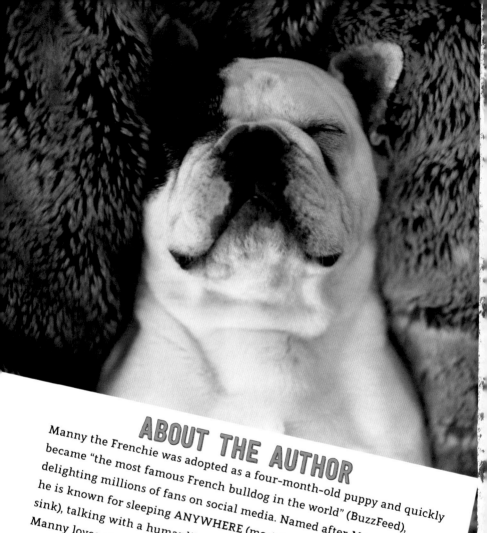

ABOUT THE AUTHOR

Manny the Frenchie was adopted as a four-month-old puppy and quickly became "the most famous French bulldog in the world" (BuzzFeed), delighting millions of fans on social media. Named after Manny Pacquiao, he is known for sleeping ANYWHERE (most famously in the bathroom sink), talking with a humanlike bark, and for his philanthropy efforts. Manny loves giving back and regularly partners with major corporations and travels the country supporting different charities while spreading his goodwill and cheer. @manny_the_frenchie, mannythefrenchie.com.